Gina Gerson

Success Through Inner Power and Sexuality

Valentina Dzherson

Gina Gerson

Success Through Inner Power and Sexuality

Prende Publishing

Las Vegas ◊ Chicago ◊ Palm Beach

Published in the United States of America by
Histria Books, a division of Histria LLC
7181 N. Hualapai Way, Ste. 130-86
Las Vegas, NV 89166 USA
HistriaBooks.com

Prende Publishing is an imprint of Histria Books. Titles published under the imprints of Histria Books are distributed worldwide.

Library of Congress Control Number: 2020946169

ISBN 978-1-59211-047-6 (hardcover)
ISBN 978-1-59211-114-5 (softbound)
ISBN 978-1-59211-159-6 (eBook)

Contents

Introduction

Success is a trendy subject these days, and there is a rapidly growing interest in how to achieve it. Today, most people, especially young people, strive for success! In my opinion, this is also due to the development of the internet and the popularity of social networks. The idea that you need to be successful means to be on trend with the times!

Unfortunately, many people don't realize what it means to be successful for themselves as individuals. They blindly follow the instructions, behavioral standards, and lifestyle imposed by modern society and the media. I believe that people in today's society have lost the ability to think for themselves and listen to themselves, to their inner voice. Very often, people are afraid to publicly express their opinions if they do not coincide with the opinions of the majority. As a result, the lives of most people unfold in the ways dictated by society overall. Most people are scared to be themselves. They are afraid to show their individuality, and they are fearful of living the way they want. They are terrified of the consequences of not conforming to social norms and standards of behavior. People are afraid to listen to their inner voice and to fulfill their spiritual needs for fear of being rejected by society. As a result, they are unable to become the unique individuals they were born to be, and unable

to demonstrate their talents and natural skills — all because they have low self-esteem!

Out of fear of loneliness, people are ready to sacrifice their individuality to conform to society's imposed standards of behavior. They even sacrifice their unique appearance to adapt to modern standards of beauty. Because of low self-esteem, people lose not only the individual uniqueness of their personality, given to them by nature, but also doom themselves to a life that they would otherwise not want to live. They miss their opportunity to live their life as they dreamed! Even when people realize that they are not living the way they want, as society, friends, and colleagues dictate to them, they still don't do anything about it because they are afraid of change. This is all due to low self-esteem, which leads to weakness and a lack of desire to improve yourself and your life! As a result, most people just go with the flow and miss opportunities to be happy and successful.

In my own life, I embrace the idea of manifesting my unique personality! I believe that each person was born special and unique, inimitable, with an individual set of talents and personal qualities that must be preserved and developed. No one can copy another and hide under the mask of a different character! Being yourself allows you to achieve happiness and freedom that provides a strong foundation for the development of self-confidence. When a person is honest with himself, he hears his inner voice, a real-life beacon that can guide a person through life. The ability to listen to your soul's voice gives you a clear understanding of who you really are and what you want to achieve in life—who you want to become, and what specific people you want to attract in your life. Thus, a clear understanding of oneself and one's self-confidence appears (which

is the basis for the development of inner power), helps a person develop in life and overcome difficulties and obstacles on their path to happiness and success.

In my life, sexuality is the driving force in my development as a person and my inner power to achieve success! I was born with a naturally high sexual drive that gives me strength and inspiration in life. It allows me to create, have inner harmony, achieve success in my business, and develop as a person. Since childhood, I have been listening to my inner voice and focusing mainly on my spiritual needs, since what my soul wants is the real me. My self-confidence helps in the development of my inner power, which has always helped me walk my own path in life, even though public opinion often tried to impose its guidelines and values on me and to cast me aside. But, my strength of character, supported by my strong sexual energy, stubbornly led me along the path of life chosen by my soul! Happiness and success mean to live the life that you want.

Since people often do not listen to themselves and the inner voice of their soul, they cannot formulate their own life goals and desires. Instead, they adopt and copy the goals and values that society dictates for them. Thus, many people program their brains with the ideas of others about the meaning of success and happiness. They live someone else's life contrary to their own dreams and ideas about success! The opinion of society is that of the majority. There is a mistaken belief that the majority is always right, but in fact, it is not! The majority is often mistaken since this majority consists of individuals with low self-esteem, afraid to express themselves and their opinions on this or that. They simply copy each other's opinions without checking or refuting the truth of their judgments or facts. As a result, a harmful public opinion is often formed, then imposed on

people through the media. Therefore, it is necessary to strengthen your own self-esteem and develop your strength of spirit and character so you can ignore the opinion of the majority and embark on your own path of development!

Very often, people think that if they become famous, this means success, but it does not. You can become famous all over the world, but at the same time, be completely dissatisfied with your life. For example, you obtain quick success through YouTube or Instagram, but what comes next? People often confuse success with material well-being, but very rich people are frequently profoundly lonely and unhappy in their personal lives. I cannot call this success. But these are the standards of success that society imposes on us. Many people blindly follow this because of their low self-esteem and lack of fortitude to create their own formula for success.

I believe that success is a personal matter for each individual. Since all people are born with different individual qualities and needs, each must fight for his or her own happiness and achieve success in their own way. One thing remains unchanged — the need to listen to the voice of your soul, your inner voice, and follow your dreams. Dream often and boldly. Believe in miracles, and gradually plan your actions to realize your dreams. Always seek to improve your personal development and believe in yourself, even if no one else around you believes in you! Each person is busy with their own life. If someone does not believe in you and your success, their opinion should not matter, since they are not you, they do not feel like you, they do not live like you, they do not want the same things as you. No one else can provide an objective assessment of your talents and potential.

I believe that success is a lifestyle involving constant personal development and self-renewal! Time does not stand still. Therefore, having achieved success once, you need to take it to the next level and improve yourself and your skills, since everything changes and nothing is constant!

For me, the main formula for happiness and success is to have a harmonious state of mind and soul. When they are in harmony, nothing can hold you back! This means that I do what my soul wants, and my mind is always looking for ways to further develop my soul's desires. When you find something to your liking, you work at it with pleasure and inspiration, you do not get tired, and you never call it work. Instead, it is a paid hobby that pleases you and inspires you to develop yourself in your business and in your life. This is real success that will allow you to achieve happiness. You will also naturally attract like-minded people around you. I discovered myself through my sexuality. In this book, I am happy to share my experiences with you, as well as my thoughts on personal development and achieving success.

Valentina Dzherson

Growing Up in Siberia

My name is Valentina, but to the world, I am known as Gina Gerson, a famous model and an adult film star. This is my story.

I come from a poor but hard-working Russian family in Siberia. My grandmother, Valentina, for whom I was named, was born in 1932 during the Stalinist era in the Soviet Union, which was during the forced period of collectivization. Grandma Valentina was like me when she was young: physically small, yet well-proportioned, with dark hair and brown eyes. She was very pretty as a girl, but not very sociable, and despite being admired by many boys, she never married, relishing her independence. I have inherited her sense of humor, irony, and strength!

Her family were successful and wealthy farmers whose land and possessions were taken away by the communists during collectivization under Stalin. She was just a child when World War II broke out.

She grew up during some of the most challenging times imaginable: the Stalinist purges, forced collectivization, and the Nazi invasion of our country. My grandmother felt like she grew up alone because her older sister, Ana, who was two years older, was their father's favorite. She learned to work hard, but she didn't receive love and affection from her parents. This shaped her personality. They only had one pair of shoes between them, and during the cold winter, she and Ana would have to take turns going to school

because they couldn't walk in the winter snow. They had very little to eat — sometimes only a few carrots. Valentina became very introverted. The stresses on her father, who found himself suddenly impoverished, made him very strict. Her upbringing and experiences gave her a thick skin and a tough character, traits that I inherited from her. Grandma Valentina was uncompromising. She was a very beautiful woman, but her personality was too strong for most men.

My grandmother Valentina didn't have any children until my mother, Galina, was born in 1974 when Valentina was 42. I never knew my maternal grandfather because my mother's parents divorced soon after she was born, and she was raised as an only child by my grandma. My grandmother didn't give Galina the love and affection she needed because this was the way that she had been raised. Everything was focused on survival in case another war came. She was very sensitive and over-protective, which made her seem harsh.

I was born in the early hours of May 17, 1991, in Russia, in a small town in Siberia called Prokopyevsk, only months before the collapse of the Soviet Union. Just like my grandma, I grew up during a period of great turmoil in the history of my country that would have a profound impact on me.

My mother, Galina, was very young when she got pregnant with me, only 16 years old. Her boyfriend was about 20 years old at the time, but I never saw him, even in pictures. Actually, I never even knew he existed until many years later when I learned the truth about my early childhood and asked my mother, "Who is my real father?"

She told me the story of how, when she was 16 years old, she met a guy that she liked very much. His name was Evgeniy. They started dating and having sex. After a few months, my mom realized that she was pregnant, but she was too far along to have an abortion.

Evgeniy's mother, Tatiana, did not want him to be with my mother because she was very poor. She didn't consider Galina to be good enough for her son because she came from a poor family. However, he secretly dated my mother because he loved her. His mother found out and sent him off to university in another city. Galina told his mother about her pregnancy, but Evgeniy still left her because he was young and not ready to take on such a responsibility. This left my mother in a very difficult situation because she was only a child herself and had not planned on having a baby. She lived alone with her mother, and she didn't have a father either.

My grandmother Valentina was a very tough, hardworking woman who always strove to take care of the family and put food on the table. She was never afraid to speak her mind. We were a poor family, and my mom and grandma worked hard in our garden to grow vegetables to feed us. My grandma also had a job at a dairy in the city nearby and was gone all day, so my mom was mostly on her own.

My mom was only 17 years old when I was born, but she was not really ready to have me or to take care of a baby. She didn't know what to do. During her pregnancy, she never felt any maternal instinct, and she thought about putting me up for adoption. She was under a great deal of stress because our family was so poor and she didn't know how she could take care of me. But my grandma told her that she would not give me up and that she, Grandma Valentina, would take care of me. Because my mom was under 18, she had no

legal right to make any decisions of her own. As a result, my grandma's decision was final.

It was many years later that I learned about all this when my mother finally told me the story. She told me about how, when I was born, she didn't even want to breastfeed me. The doctors gave me milk from surrogate mothers, and my mother would squeeze her breast milk into a glass to feed me. One day, one of the doctors at the hospital where my mom was staying after my birth, said to her, "Galina, you know I have a good life, and a good husband, but I have no kids. I would be happy to adopt your baby and to take good care of her." My mom agreed to this, but my grandma refused the offer and said that she would keep the baby. Since my mom was still a minor, my grandma's decision was final. The doctor persisted and came to Valentina's home and saw how poor she was. The house was in disrepair, as it had been built on swampland, which destroyed the foundation. The doctor offered money, but grandma again disagreed.

So, my mom and grandma brought me home from the hospital and took care of me. Three generations of women on their own! About a month after I came into her life, my mother's maternal instinct kicked in. She no longer wanted to give me away to anyone. So, for the next year, I was raised by my mom and grandma in a small village called Usiata. We lived in an old house, with no man in our lives, and it was very hard for my mom during that time. The house was so cold that my mom had to send me to an orphanage for three months so I wouldn't get sick and die. The house was really old and decrepit, and she was scared to be alone there. Strange noises would come from the ceilings and the walls, and she was always afraid that they would cave in on us. My grandma planted a large garden in the

backyard so we would have fresh vegetables to eat. My mom continued going to school and worked in the garden while Grandma went into the city to work at the dairy, where she was in charge of the production of all kinds of milk products. At home, she would help my mom in the garden.

After about a year, my mom, Galina, met my stepfather, Alex, with whom she would live for the next 17 years. He was a young boy, the same age as my mom, and it was love at first sight for him. My mom was a uniquely beautiful woman, and Alex was a tall, skinny boy, although as he grew older, he filled out. He had short dark hair, green eyes, and broad shoulders. He had lost two fingers on his hand in a childhood accident, but that didn't stop him from doing anything. He was a possessive and bossy character and would change his personality to please those around him. He always had nice cars, and he dressed well to impress society. Although she had no money for makeup or fancy clothes, purses, or nice shoes, her personality drew people to her. She was very kind and very charismatic, with a beautiful smile, dark hair, and a lovely voice. Alex told her, "I want to bring you home to meet my family." Shortly after she met them, my mom and I went to live with Alex and his family in their apartment in the city. So, by the time I was one year old, I finally had a complete family. Alex told his mother that I was his baby. However, my mom told her the truth about her relationship with Evgeniy and how badly his family had treated her.

Alex's family treated us very well and made us feel like we were part of their family. Of course, we often visited my grandma Valentina in the village where she lived by herself. In the beginning, Alex was very loving and caring toward my mom and me, even though my mom didn't really love him. Still, he adored her and

offered her a home and family. This was what had been missing in her life.

My step-grandfather, Anatoly, was very kind to me, and I enjoyed spending time with him. There was a lot of conflict between my step-grandparents—perhaps they were too much alike. But Anatoly had become wiser with age. My step-grandmother, who was called Galina, like my mom, was one of the kindest people I had ever known. She truly loved me and treated me as if I was her own grandchild. She was a very loving and caring person, and she was a mature woman who knew how to raise children, which neither my mom nor Grandma Valentina knew much about. She became closer to me than even my mom was, and became my ideal of female love. When she suddenly died of an aneurism when I was 14, I was devastated. She died while she was at her job working as a nursing assistant for the ambulance service. Her loss greatly affected me because I loved her so much, and I spent my breaks from school each year with her. She was one of the most influential people in my childhood; I felt loved and protected when I was with her. She really taught me so much about life, and I would listen to her. If my mom or Alex said something to me, I wouldn't listen, but I always listened to Grandma Galina! I mourned her loss for over a year. I dreamt about her and kept her memory alive. After her death, I wasn't afraid to lose anyone anymore because I knew I had to make it on my own, and I couldn't count on anyone else to be there for me. Things changed after she died, and I realized that nothing lasts forever.

The only time I was ever jealous was when I saw her kiss my cousin on the cheek twice and me only once when I was about ten years old. I was so jealous! Later I asked Grandma if this meant she loved me less. She told me no, she actually loved me more but didn't

want my cousin to feel that, so she kissed her twice. After that, I was never jealous again. If someone loves me, they do, and if not, it isn't something for me to worry about.

Throughout my childhood, everyone told me I was very pretty, and I received a great deal of attention.

We moved out of Alex's family apartment when I was four or five years old, and we lived in our own place in the city, just the three of us. During all those years, I never knew that Alex's family was not my own flesh and blood. They were a very loving family, and I felt totally accepted by them. We thought life would be good.

However, at this time, Alex, my stepfather, became more heavily involved in criminal activities, and he started to become more violent toward my mom. The relationship became very toxic. He became increasingly jealous of her and was constantly obsessed that others might take her from him. He wanted her to stay home and take care of the house. He knew he didn't deserve her. Everyone she came into contact with loved my mom because she was a very sweet and caring person, but Alex said if she ever left him, he would destroy her life. The Mafia influenced him, and he became a dictator in the house. My mom didn't know any better and felt trapped in the relationship, living in fear because the police could show up at our house at any time, day or night. Even though they lived together, my mom was never involved in any of his business or criminal activities. Still, she worried that the police would come and search the house looking for something illegal, such as a gun.

Alex never worked at a regular job. He was a young boy when he joined the local Mafia. It was the 1990s in Russia, and people did whatever they wanted; there were no longer any strict rules, and the politicians did nothing to make the situation better. It was all about

gangsters and the Mafia — all kinds of different rackets — the crazy things you see in the movies were happening then: protection rackets, illegal gambling, blackmail, robbery, and even murder. Everyone knew what Alex was doing, but no one could control him.

As early as I can remember, I harbored doubts about my stepfather. I just didn't feel any emotional bond, nor did I see any physical resemblance between us. He never accepted me as a daughter, and there was always an underlying tension between us, even though at the time, I didn't quite know the cause of it. He began to regard me as competition for my mom's attention. I remember my mom even took me to the doctor when I was around seven years old because I exhibited signs of stress after I saw him physically abuse my mom and slap her face. That really hurt me, and I began to view Alex as the enemy in our home.

My doubts were confirmed around the time I was 10 years old, and Grandma Valentina told me that Alex was not my real father. My relationship with Alex was complicated. He tried to make me feel insecure, but I understood that it was just manipulation on his part to hide his own insecurities. I saw how this worked on my mom, but it didn't work the same way on me! There was a lot of verbal abuse, but I learned to give as good as I got, maybe even better, using black humor and biting sarcasm. He was ambitious, obsessive, and controlling, and his way of thinking influenced me over time in unexpected ways. He always thought about the easy way out, how to lie, cheat, and steal to get what he wanted. My stepfather became a negative role model for me, teaching me how *not* to be, and he would never apologize for anything.

My mom cooked and cleaned and took good care of our home and all of us. She was a perfect housewife, but one could always feel

the lack of love between her and Alex. The fact that she did not show him any love made him angrier and meaner. All of his friends were also gangsters, and because our families were friends, that was the environment I grew up in. I would play with the kids of other Mafia people. At home, we would hear the adults talk about stealing cars or stealing money. As kids, we played these sorts of games. It's not that we dreamed of becoming gangsters; it was just the world we lived in. For some reason, when I was very young, little girls never wanted to play with me. My mom says I was a little bit wild and aggressive, kind of a tomboy. The little girls played with Barbie dolls, but I was usually playing war games with the boys. However, at home, I still played with Barbies.

As a little girl, I also took some karate lessons two or three times a week to learn how to fight, which my mom signed me up for. I had a conflict on the first day and eventually got kicked out for beating up a boy for making a comment about my mom. Then I went to ballet school. For one day. I think this was due to the influence of my stepfather. This is how the world works. When kids would say bad things about me, I would beat them up. I did this to protect myself. I would always fight back when attacked.

For this reason, a lot of the other kids were afraid of me. I attracted the same type of kids around me, and I was kind of like a gang leader. I understood at an early age that you either had to take control of a situation or else others would take control of you. Of course, growing up around Alex influenced a lot of this. I was fighting with the world outside to survive the world inside, compensating, with no fear of the police.

My situation at home influenced my behavior as a young girl. I had an aggressive attitude, and I always surrounded myself with

boys and other Mafia kids who came from similar backgrounds. We realized we could relate to each other. Our games always involved imitating the illegal activities that framed our lives at home. When I was about seven years old, my mom asked me what I wanted to be when I grew up, and I responded in all seriousness, "A drug dealer!" This was because of Alex's influence. I didn't use drugs, but I heard you could make a lot of money selling them. Obviously, my mom was very upset. She cried and begged me to promise on her life that I would never be a drug dealer. I had another dream job, which was to be a stripper, a beautiful woman, dancing sexily and having people give her money.

I never did drugs, though. It was all about power. I was the smallest in the group of kids I hung out with, but I was always the boss, like in a gang. I was a tough little girl in grade school. If anyone talked bad about me, I would beat them up. If someone tried to beat me up, I always fought back. I learned early on that if you didn't fight back, they wouldn't respect you.

Growing up this way, I never felt the love of a father. I really have no idea what that is like, so I can't say miss it. My stepfather never really felt any love for me. He was just a young man, and, in many ways, he felt jealous of me, as my mother naturally directed her love and attention toward her child. However, when I became a teenager, I grew braver and started to talk back to Alex.

Other changes also happened as I entered my teenage years. At the age of 13 or 14, I started to become more feminine, and I gave up fighting. My interests now turned to dresses and make-up, as I always wanted to look as perfect as my mom did. My mom had started to dress nicely since she now had some money from my other Grandma, who worked as a nursing assistant. My mom began to

work with Grandma to make her own money, and sometimes Alex gave her money. She was my role model for physical beauty. My mom taught me how to dress, and showed me how to use makeup, take care of my hair and nails, and give me advice on how to look beautiful. She didn't allow me to overuse make-up, but she did allow me to use perfume. She supported me in my desire to look attractive. She didn't oppose me having a romantic relationship; in fact, she encouraged me to have a boyfriend.

I was proud of my mom—she always made such a good impression on everyone at school or when we went out in the city. This intimidated the other girls, and as I wasn't the kind of person to approach other people, I didn't have many girlfriends. I kept company with people I considered loyal and strong, people who really liked me. As a teenager, I attracted a lot of attention from boys, not in a sexual way, but in a sweet, innocent way. I learned that I could get them to do things for me whenever I wanted. Some girls were mean and hated me, while others were attracted to me; two sides of the same coin in many cases. I always strove for perfection for myself. As a result, many people admired and respected me, while others didn't like this about me. I was still the smallest, but an inner power to be the strongest always drove me, and I was an excellent student and got good grades.

Although my family wasn't very wealthy, we still managed to survive somehow. My mom didn't have much education, as she had me while she was still in high school, and she never attended university because Alex would never allow it. He wanted to control her and make her dependent on him. He was also jealous that she would meet other men at the university. Later, she took some night classes to acquire new skills. Thanks to my step-grandmother,

Galina, my mom got a job as a nursing assistant at an emergency clinic, where she worked part-time. I would sometimes run away from kindergarten to see her, as the clinic was nearby. She worked day shifts, and sometimes night shifts, going along with doctors on house calls. It was challenging work.

Alex, my stepfather, also didn't finish school. Instead, he began his involvement with the Mafia. His criminal activities made life complicated, but we survived as best we could. Life had its ups and downs, but over time, Alex became more established as a gangster, recognized as a leader by the group of people with whom he worked. He always tried to give the impression that he had a lot of money. He wanted to look rich, dangerous, and powerful by wearing expensive clothes and driving a Mercedes. It was all a façade. He would spend all his money on this, even when we had nothing. This illusion worked well for him. I learned from him how to pretend that you are something that you are not and how to adapt to every situation. Alex could act charming and kind, but at other times, he would be very tough and powerful. He used fear and intimidation, especially with other men.

However, the relationship between my mom and Alex had deteriorated over the years. At the age of 15, I saw him physically abuse her. I saw him slap her across the face in the kitchen when I came home from school, just as had happened when I was 7 years old. For me, it was like dèjá-vu. Nothing had changed in all these years. It made me realize that the only person you can change is yourself. I knew there was nothing I could do—only my mom could decide to make a change, and I couldn't involve myself in their problems or waste my energy on them. When I was only seven, I was scared, but now I just took my mom out of the kitchen and ended the

fight. They argued all the time. He cheated on her, and eventually, she started cheating on him. Finally, one night after I had already moved from home to attend university, she'd had enough and just packed her bags and left.

From a young age, I realized that life could be complicated, primarily because of my stepfather's lifestyle. When we moved out of my step-grandparents apartment, I started kindergarten, and I remember that many times, late at night, the police would come to our door. They would kick it in, then search every inch of the apartment, looking for a gun or other illegal items. They would even look inside my toys, under the bed, in the closet, and through my mom's things. From the conversations I overheard, I realized that they were looking for a gun. The only thing they didn't check was the inside of my panties! Several times they took my mom and my stepfather to the police station for questioning, and I realized that Alex was involved in some terrible things. The police took my mom in also, not because she had done anything wrong, but because she was part of his family. My mom was not involved in Alex's business, and because I was left at home alone, they would let her go after a few questions. However, the length of time the police left me alone for when I was only seven or eight years old was not suitable for a child, but it did make me a stronger person. My stepfather would also be released after a few days because the police did not have enough evidence to hold him.

Life was the same, year after year. Alex would leave in the morning and return in the evening. His friends would come over and discuss some of the illegal money-making activities that they were involved in. I was just a little kid, but I already understood that life has no rules—or that all rules can be broken. They would discuss

ways to defraud the bank, make money through blackmail, and other things of that nature. Such was the life of a local Mafioso. It was painful for me to watch my mom have to endure all this, even though she had no involvement with his activities. I can say that Alex loved her but in a sick, obsessive way. He always feared losing her and didn't want her to work, saying that he made enough money to support us, but it really was a way to control her and keep her dependent upon him. I could see that my mom wasn't really happy the way a woman should be. I realized from a young age that two people could live together but not truly be happy.

Although she had harbored doubts when she first became pregnant with me—which was perfectly understandable for a teenage girl—growing up, my mom always loved me with all her heart and soul. She gave me all the love she had, and I never felt that anything was missing. Both of my grandmothers loved me also. I never felt that my grandma on my stepfather's side was not my real grandmother because she gave me unconditional love. In general, I was a happy child; the only thing that really affected me was my mom's lack of happiness. My step-grandfather also treated me as his own flesh and blood, and he would often take me on trips to the lake or the forest to collect berries or mushrooms. He spoiled me as much as possible with candies and fruit, but I was never what you would call a spoiled child, maybe because of my stepfather, who never really showed me any love. It was a family without harmony. He didn't show my mother real love, and as a result, he didn't get that love in return.

Growing up, you could say I was like a little bandit, and most of my friends were little bandits too. We lived in a small town in Siberia, and because of my reputation, some of the other kids were

not allowed to play with me. It didn't hurt my feelings at the time because I always had other kids around. Besides, I was like a little Mafia boss in my group. Even as a child, I enjoyed wielding power.

My step-grandparents really loved me and always gave me treats and took good care of me. I learned from childhood what unconditional love was about. (For this reason, as I grew up, it became easy for me to recognize fake love.) From my family, I learned about real love. But there was a lot of stress within the family. Because of the criminal activity of my stepfather, we moved often. My mom left him sometimes, and then she went back. She was very unhappy, trapped in an abusive relationship, but she always showed me love.

Once I started school, I changed schools often (five times in all) because we had to move because of problems with landlords and neighbors. This was stressful for me as a little kid because I had to go to class and meet new people all the time. I always felt like an outsider. Everyone else knew each other, and the new kids were usually bullied. I was often the smallest, making me an easy target, but I knew I had to fight back. After changing schools three or four times, I knew exactly what to expect and was always ready.

I became used to fighting to get by, but I was never completely alone; I always had a few loyal friends who stood with me. The need to defend myself made me a stronger person because I always felt that I had to win or die in any confrontation. If a group of kids tried to attack me, I would fight back. I knew that if I won, they would respect me, and if I lost, I would be bullied all year. Being a kid from a Mafia family, I learned early on in life how to break the rules. My school life was challenging, and I earned respect by standing up for myself, but also because I studied hard. I was a very good student,

so I won over most of the teachers to my side. I was smart, and I could think. I realized that intelligence could give me power. Boys generally liked me because I was pretty. Few girls liked me, though. Many of them viewed me as a rival. Because of this, most of my friends were boys.

As my stepfather became further involved in Mafia activities, the police visited our home more and more often. Every summer, I went to a youth camp in the countryside for three months. We had morning exercises, competitions, trips, discos, and you had to have 'connections' to get in. I was very popular there; some people loved me, and some hated me. There was a lot of freedom, and I always got close to the counselors. I saw myself as being different from the others. I had my own ideas and opinions, and I always liked to share them!

We'd sneak out at night through the window and go to the boys' room, just playing and having fun, breaking the rules. We always tried to skip calisthenics. I didn't want to be home for the summer; I wanted to be away from home because of Alex, but Mom came to visit.

I never experienced the love of a father. It is something I never missed because I never had it. Other kids had it, and one day, when their father died or went away, they felt a sense of loss. I never had this, but I had love from all the other members of my family.

Even though there was a lot of tension in the house, we still did things as a family, such as going on trips or vacations. However, I always preferred just to be with my mom. As I became a teenager, I started to feel more hostility from other girls because I was beautiful. Friends of my stepfather began to notice my beauty and call me 'jailbait.' No one ever tried to do anything to me, but I learned to use

the power I had over men. I quickly realized that I could use their desires to my advantage.

My stepfather was always very critical of me, and he would pick on me for little things. As a small girl, I listened, but as a teenager, I learned to talk back and to stick up for myself. Alex was very insecure, and I needed to prove that I was in charge. I learned to play the game. Sometimes I would act as if I agreed with him. I remember once he was yelling at me for not doing something around the house, a typical fight, and he came up in my face and pushed me against the wall. I looked him straight in the eyes and didn't back down. He just walked away. He hadn't expected my reaction, and he realized I wasn't a little kid anymore. These were the same techniques he used in extortion. He tried to scare me. When he realized this didn't work, he was afraid to lose power, and he would use other methods. My mom couldn't fight back. When I wouldn't listen, he pushed her more, covering his fear with aggression.

My mom began to cry more often, so I told Alex I didn't choose this kind of life; it was their decision if they wanted to live like that. If I showed I cared, he would use it to hurt me more by manipulation; my mom was afraid for both herself and me. She chose to be afraid. I chose to live and *not* be afraid. If it was a case of live or die, I chose to live.

For some reason, my mom and Alex never separated, even though there was no love or happiness in their relationship. I started to realize that he became more aggressive toward me to fight his own sexual desires that he couldn't act upon. We never had any father-daughter type relationship. As a teenager, I came to realize that I had power. But because I had an aggressive father at home, I was never

afraid of men. I never backed down in life, and this has also helped me in business.

As a teenager, my stepfather got into some trouble with other Mafia people. For her safety, Grandma Valentina left the village to stay with us in the city. While she was away, his enemies burned her house down. I was ten years old.

I called Alex 'Papa' because he had asked me to do this from early in my childhood, but even before I learned that he was not my biological father, I never felt this type of connection.

At the age of ten, me, my mom, my grandma Valentina, and Alex lived together. Alex and Grandma Valentina were both dominant personalities, and they did not get along. She would only visit when he was away. But when his Mafia rivals took revenge and burned Grandma's house down, she had to move in with us. Grandma didn't like Alex, but she had no other choice.

As I grew into an attractive teenage girl, Alex would always tell me things like, "Don't get pregnant like your mom." When I came home at night, he would always check to see if I smelled of alcohol or cigarettes. He would try to check out every boy I had contact with. It wasn't that he really cared; it was that he wanted to control every aspect of my life; my school, my friends, what time I came home. The pressure from him increased when I was a teenager. I think this was due to all the sexual tension he felt.

Because a lot of boys liked me, most girls didn't, especially the older girls. I had to learn to avoid conflict because, as I grew up, I didn't want to fight any longer. So, I had to learn to use my mind to make them respect me, using words instead of actions. To make girls respect me without using physical violence wasn't easy because they would talk behind my back a lot. Even at this young age, I felt the

power of my sexuality, and I never felt that I was in competition with anyone. I also felt physically attracted to females and fantasized about teachers and other schoolgirls. Sometimes teachers would touch me, but more in an admiring way rather than a sexual one. If you are smart, intelligent, pretty, and sexually powerful, it attracts people to your side.

I studied hard in school and learned my lessons. I was very intelligent, beautiful, and sexy. Even women told me this, and when they said how beautiful I was, it really meant something. People seemed to either love me or hate me. I never tried to be the center of attention, but I enjoyed teasing people, even those who hated me. I learned to manipulate people by using my sexuality, and I found that it gave me power, and it always motivated me to be smart. I was well-groomed, dressed well, and took care of myself. I never wanted to be the stereotypical dumb blonde girl, so I worked hard in school. I had no interest in parties, alcohol, or drugs when I was in high school—not because my stepfather was constantly checking on me, but because I just never had any interest in them.

When high school ended, I wasn't sure what I wanted to do. I was good at French, so I decided to go to university to improve my foreign language skills. Other kids wanted to become doctors or teachers, but I wanted to become a diplomat. People told me this would be impossible; I didn't have the money, I was blonde, I looked good, and because I was a girl. Also, my family didn't have the right political connections, so no university would take me. This just motivated me all the more. If I wanted this, I knew I could achieve it because I was smart enough. All I had to do was work hard. So, I prepared myself for the entrance exams. Grandma gave me the

emotional support I needed to achieve my dreams. Mom wanted me to be more realistic and do Plan B.

To everyone's amazement, I passed all my exams and was accepted into the faculty for diplomats at Kemerovo, the capital of District 200 KM, as well as to the linguistic university. I was very proud of myself. I just wanted to prove myself so that I could achieve my dream. I had no interest in politics. I showed my inner power and proved I could do anything I wanted to if I set my mind to it — but I asked myself, "Do I really want this?" I chose the more pragmatic solution and decided to attend the linguistic faculty at the University of Tomsk, about 600 km away from home, where I received a full scholarship. I had fulfilled my goal of free university tuition! I was thrilled to leave home. I wanted to live my own life. I felt like a painter ready to paint my own canvas. I wanted a job, money, and respect. I wanted options, such as to be a professor or translator. I knew I wouldn't like diplomacy. I wanted to be a lawyer, but there were no free places available, and I couldn't afford the fees.

I learned that all responsibility is within yourself. If you are strong enough and have inner power, no one can hurt you. No matter how small you are, whether you are a boy or a girl, all your power is inside yourself. Sexuality is part of that power. Energy is part of that power. It makes your body produce the right hormones because of your sexual power. You become your own angel. I always felt like I had an angel looking over me.

My mom broke up with Alex two years after I left home. He had trapped her, and she only stayed with him because of me. He would put her down, and he would always take her back, but he'd threaten to ruin her face. Like I have said, I never saw or talked to Alex once I started university. I think that deep down, I hated him. Conflict and

fighting might have been the only solution for us, and worse things could have happened. Alex and my mom continued to live together for another two years after I left for the university until one day, my mom came home and found two glasses of champagne on the table, one bearing the lipstick of another woman. We think he did it on purpose as he didn't have the courage to break up with her. She realized that he was cheating on her, so she just packed her bags and left.

Interestingly enough, my mom saw Alex with his new wife, and she said that she looked a lot like me — a small, petite, blonde woman.

No one ever tried to influence me, but I believed that marriage between a man and a woman should be based on love. There must be love, respect, care, and harmony in a family. I always had the idea that I'd be married and build a life together with my husband, which is why I stayed a virgin for a very long time. I was waiting for my Prince Charming. I didn't find him. I wanted to have a perfect family, no divorce, no cheating.

As I became an adult, I realized that my concepts of sexuality did not match up with my idea of a family. I am a sex performer. This is my lifestyle. It is not forever. Eventually, I want the same things I always did.

My bisexuality began in childhood. I would admire older girls. I didn't think about having actual sex, but I wanted to touch them, and I fantasized about it. I am very sensitive to touch. I felt sexual attraction to other girls or teachers, and I had some fantasies. My teacher was giving a lesson while I daydreamed about how I would kiss her and touch her. I was attracted to her intelligence. I don't know if this was healthy or sick because I didn't share these thoughts

with anyone. I was in love with the principal, who was very beautiful. She was happy to have me at her school.

Once, I lost my gold pendant. I went to her to report it. I was about 15 years old at the time. She locked the door and told me to undress. I thought this was quite unusual, but I also had a sense of excitement when she helped me take my clothes off. Once I had stripped down to my bra and panties, we found the pendant stuck in my bra and had a good laugh. I remember hoping that the principal would kiss me, but nothing more happened. I got dressed and returned to class. But she made a great impression on me and because of her I am still attracted to older women.

Some of the teachers really liked me. They would touch me differently than some of the other girls. They could feel my sexuality, and they responded to it. I was always a teacher's pet. They would have me sit on their lap, hug me, and touch me. I never liked gym class because I would get too sweaty. The principal would not force me to go; she and the teachers always protected me. I was very okay with that. They admired me and would comment on my body and how perfect it was.

Touching and kissing were always the most important things to me. There were many different girls, from young teenagers to older women, who I was especially attracted to, particularly the teachers. I might not have had so many fantasies if they hadn't responded. I had an attractive body and stayed in good shape; already, at the age of 14, I had a regular training routine. I did my exercises every day at home, so I didn't need to go to the gym. I worked on my abdomen, doing sit-ups and pushups. I was proud of my 'six-pack' and worked at it consistently. I had a great deal of discipline!

I always wanted to be sexy, and I thought about sex a lot. I liked the teachers but was afraid to make the first move. Touches and hugs gave me a special feeling. Age doesn't matter to me when it comes to sexual attraction, but I often found myself drawn to women of about 40 years old, maybe because that was the age of many of my teachers. Sexual norms in Siberia forbade lesbian contact and opposed homosexuality. This led to repressed feelings in girls, who converted it to anger, while others hid it in friendship.

I never played sexual games with other children my age, such as 'show and tell' or 'spin the bottle.' If I had wanted to and had thought about these things, I certainly could have, but I just never did. Teachers would kind of flirt with me in an innocent way and say how pretty I was, but they didn't realize what this did to a child's imagination. Even when I changed schools, I always wound up being the teacher's pet.

I grew up around boys, and it was difficult for me to think like a girl, so I had trouble making friends with other girls. I was only friends with girls who wanted to be friends with me. I still have problems with friendships with other girls.

My conflicts with girls started around the age of 14; girls always seemed to be against me for no reason, and would always reject me. I didn't understand it at the time, but now I realize that it was all due to sexuality. They thought, *If I can't have you, then I will be against you.* They were too shy to say they liked me because I was sexy. Boys told me they didn't like me because I was smart and sexy, and all the teachers liked me. So, they were jealous. They were afraid of rejection, so they decided to be against me instead.

It was the same with Alex; the sexual attraction was transformed into aggression. At around the age of 17 in high school, I had a lot of

pressure. Girls would pressure me, and guys wanted to protect me from them. I thought it was so funny. I always kept my hair and nails nicely done and wore perfume, so I smelled good. I took after my mom; looking good was more important than eating breakfast for me! I would wear a thong, even in the freezing cold of Siberia, just to look and feel sexy, and I wore short skirts and dresses. I didn't wear a hat, even in the cold, because I didn't want to mess up my hair.

Looking back, I can remember how I never felt that I fit in whenever I changed classes or schools. I wasn't immediately accepted because others felt that I looked and acted differently. And every time I changed schools, it always took about half of the school year for me to make one or two friends, but that was enough for me. I never wanted to have a million friends because, for me, it was okay to have lots of pals but not real friends because real friendship has always been important to me since I was a child. I was content with having just one or two friends with whom I spent time. Also, I felt that some of my friends and I were different because we took everything to be temporary. I never got attached to people or institutions and never missed the schools I left — I was always connected to myself. Even when I had to leave my best friends behind because my parents were always moving house, I was cool with it because I felt that nothing was permanent. Nobody taught me to live that way; it was all me. And once I got to a new place, I made new friends — always a maximum of two — usually a boy and a girl. I didn't push people away, they just didn't interest me, and I was always caught up in my own activities.

I remember when I arrived at my last gymnasium, where I spent the last three years of school, I moved there with a girlfriend from my previous school. She was studying mathematics, and I was

studying Russian language and literature. We separated, but I remember her as my last close girlfriend before I left for university. Her name was Elena, and she was very good at her studies. I also had another friend, Alexander, who was my best friend, and we took the same classes. I believe that he was secretly in love with me but too shy to tell me. I didn't like that the females were always together in groups — going to the toilets, walking along the corridors, etc. That was why I got close to Alex and Elena from the parallel class. Having lots of people around me was never as important as having my soulmates around me. I also remember how the whole class turned against me for no reason; the females didn't like that I was classier than them, and the boys just agreed with them. Alexander was the only one who supported me.

The main teacher for our class was a woman who taught Russian language and literature, and I remember that I found the grammar of the Russian language very difficult to learn. I knew all the rules of punctuation, and I knew all the tools, but I could not write it correctly. I have always had this problem, but when I came to the gymnasium, it was worse because the teacher didn't like me, and we had communication problems. This was strange because the other teachers liked me and appreciated that I was beautiful, cute, and smart. They were always interested in how I was getting settled in at the new school. But this Russian language teacher was literally killing me. In the middle of a lesson, she asked me questions, which I answered and then all of a sudden, she said, "Hey, why are you looking at me like that? Don't look at me like that because it is silly." I said that I was sorry, and I asked her, "How did I look at you?" She replied, "Like you are flirting with me, and you cannot look at anybody like that." The whole class was silent, and they were looking at me. So, I asked Alex, "Hey, how did I look at her? What is

wrong with my eyes?" He told me that nothing was wrong with my eyes, and nobody had ever mentioned anything about my looks, but this teacher said that more than once a week. I didn't like her, and I didn't care for her personality. Clearly, I had a problem with the Russian language, but other people had even worse problems. Imagine that you're a teenager of 16 or 17, and your teacher is always saying that to you!

That was my relationship with that teacher, but I understand now that she really liked me, and this was her way of showing sympathy toward me, because where there is hate, it is usually the result of some sort of attraction. However, I didn't feel any sympathy toward her; I was just tired of all the negative attention. This affected my communication with my pals because she was the main teacher for our class, and they all listened to her.

One day, I went to the principal and asked her to change classes for me, but she refused because I was so good at French and literature, and she said that the class was the best one for me. I remember coming home and crying to my mom, "Mama, I don't know what to do with that fucking teacher!" She wanted to go with me to school, but I asked her not to. This continued until I went back to the principal and told him that I got in trouble with the Russian language teacher, and she was always complaining that I looked at her in a certain way. I told her that this had severely affected my reputation in the class, and it had pushed me down. The principal found this hard to believe because she saw me as a very positive, bright, and responsible student. After that, the next time the teacher came to class, she was different, and she never told me anything from that day on.

It was a crazy situation, but from it, I learned that I couldn't control how other people felt, and I shouldn't allow it to affect me. I couldn't have dealt with that situation without the principal's help, but I understood that things like that could happen in life, and I had to work on my inner power. I still don't know how I looked at her because none of the other teachers ever complained — it was fucking tough having someone say that to me for three years. Again, because the other girls followed in her footsteps, it was like I was against society when I was in class. I felt I was better than they were because they were aggressive, and I was not; I also knew that it was all temporary.

I discussed it with my mom, and she just didn't understand. I talked to my friends, and they told me that I had to accept the fact that some people wouldn't like me because I was different. Some girls from the higher classes also didn't like me, and I felt that someone was going to kill me in that school one day, but thank God I had Alexander with me. He said to me, "You know what? I will always be around you in case someone gets crazy, angry, or something," and he *was* always around me — it looked like he was my boyfriend, but we were just friends. He always carried our books to school, and I helped him study because I was intelligent enough to make up for both of us. Since that time, I only accepted gentle and caring guys around me.

So, up until my last year in school, I hung out mostly with Alexander and Elena, and that was enough for me. I also took part in social activities and sporting events at the gymnasium, so I didn't even have time to think about all that — I was just into people who liked me. However, I knew that things were temporary, and even my friendship with Alexander and Elena was not going to be permanent

because the three of us were going to different universities in different cities. I took the separation better than they did. I truly loved them, and they were my soulmates, but it was time to move on. We kept in touch for two years after that, and then we didn't anymore. So, I can say that I don't have any friends who have been with me from childhood, school, or university — nothing is permanent. I have great memories from childhood and school, but people come and go, so my heart is not broken.

My gymnasium, or secondary school, was based on philology, which means that I took literature, Russian language, and French language. I had many passions, but I was really good in literature class, as in the analysis of a text, where a person writes one thing but means another, and you have to analyze that. I was also perfect in French, and I studied everything French in depth. I was one of the best. I was also good at physics, and I was able to find out anything whenever we did control work or analysis of any kind. The teacher usually gave us control work exercises, and we had to score very high. I was also good with geometry; for example, if you were given only one angle in a triangle, and you had to find the other sides. And I was generally good at anything involving the use of logic and analysis. But I was so bad at writing the Russian language. Strangely, my French was better than my Russian, and even before I met my teacher, Victoria, I was like that. I have always been bad at Russian, and this problem has dragged on to this day. It is quite ridiculous that I have always been good at other disciplines but not Russian. I am 28 now, and when I text my mom on WhatsApp, she still tells me, "Valentina, this is wrong. You cannot write as you hear!" I don't feel embarrassed about that, because I think that this is something specific to me. And I always tell my mom that it doesn't matter to me that my writing is incorrect; I only care that people understand what

I am saying. I may not be perfect, and my writing may be bad, but when it comes to communicating my ideas and feelings to someone else, I do a great job. I can't write correctly, but at least I can speak correctly.

Sexuality gave me power over people, something I understood how to use to be in charge, and I always received special tips or favors because of my looks. I didn't use much make-up, only a little mascara. I always tried to look like a classy, sexy lady, just like my mom. Other girls didn't care about those things, but I wanted to be the best at whatever I did. Sexuality, as a kid, can be challenging and funny. I often felt isolated because the girls didn't accept me. But the boys and teachers accepted me. I only had one or two girlfriends, usually never more than one at a time. Boys didn't represent a challenge, and many boys fell in love with me. I knew I could have them, and I enjoyed their attention. Many were very loyal, and I appreciated that. I never had a bad experience with men. I would use them, and they would be around to protect me and to help me, but I had no special guy. I always had guys chasing me, but I never gave in to them.

So, I had no real boyfriend. I like forbidden things. Maybe this is why it was so hard to find a prince. With women, it was taboo and forbidden—and exciting!

Ever since I was a very young girl, I had boys around me. Sometimes they would say they were my boyfriend. Of course, when you are in kindergarten, there is nothing sexual about it!

Sergei was the son of one of Alex's Mafia friends, and a year older than me. He would protect me, bring me flowers or candy. We would listen to our parents talking about some bad thing they had done, like stealing a car and then cutting it up in pieces to sell. We

would hear this and then decide to go out in the streets and steal a bike or something. I wanted to give it back after we had used it for a while, but Sergei always wanted to keep it. But people saw us, and all the neighbors knew that Sergei and Valentina stole the bicycle.

As kids of Mafia people, we just tried to copy our parents. I remember once hearing how they kidnapped a person, beat him up, and kept him in a basement. Sergei and I went out and beat up a little kid for no reason. This made the other little girls afraid to play with me. I know it sounds weird, but we didn't know any better, coming from the families we did. My mom told me this wasn't good, but she never punished me because she knew the source of my behavior.

I hung out with Sergei until I was about nine years old because we lived in the same building, and our fathers were very close to each other. He was a handsome little boy. Of course, at that age, things didn't go very far. I remember we kissed once, and we played 'show and tell.' That was the extent of it. We weren't old enough to think about sex, but everyone considered us a little couple, and he always told me he was going to marry me. Of course, as I grew up and became a teenager, I decided I would never have a boyfriend or marry someone with a Mafia background. I had learned all too well what that lifestyle would bring. I always rejected criminal boys or boys from criminal families who tried to flirt with me. Even if I liked them very much, I would still reject them.

As we grew older, I moved to a school in the city. Sergei remained in our old school, and we grew apart. Sergei remained a criminal boy, but I outgrew that life and left him behind.

My next boyfriend came around the time I was 12. His name was Daniel, and he was an 'older man' at 15. He was my first official boyfriend. We hung out together, but again, there was nothing

sexual. Alex didn't know about him, even though we dated for about nine months in secret. We kissed and hugged. Daniel had some sexual experience, and I was a virgin, but he didn't push me to do anything; maybe he was afraid of my father! Our relationship caused my girlfriend, Anna, to reject me as she had previously been Daniel's girlfriend. She said it wasn't a problem, but that changed. Her rejection was very painful for me because she was my only girlfriend at the time. It was my first experience with female jealousy. I didn't want to have sex because I had very traditional ideas about love and marriage. Daniel was a sweet boy, very gentle, but strong, and from a good, normal family. My mom knew I was dating Daniel, but I didn't talk much about him. Alex was always checking up on me, so I learned to hide things more and more. If he knew I had a boyfriend, he would want to know all the details about him and control everything. As it turned out, Anna, my girlfriend, was still in love with Daniel, despite her telling me it wouldn't be a problem if I dated him. I just didn't want to deal with the drama, so I stepped aside. It is a waste of energy to get involved in senseless drama. Even to this day, I try to avoid drama.

Every year I went to summer camp. This was something of a privilege, and my mom and Alex always tried to arrange this for me. Every summer, there were boys who liked me. I was around 16 when I met another boy named Sergei. This relationship was more serious than the one with Daniel. Sergei was a very romantic boy, and he would bring me flowers. I felt that I had fallen in love for the first time. You could call it puppy love, but I didn't have sex. I told him I wasn't ready yet, so we just had a lot of hugging and kissing. Sergei was a short 'love story' for only about three weeks. We chatted for a while after summer camp, but a long-term relationship was not in the cards.

Alex was always afraid that I would get pregnant, but I think he just enjoyed conflict and control. He didn't know anything about my life outside of the house. We really never spoke about anything. All we did was fight or just keep silent. We had a very strange relationship. He couldn't have me, so he didn't want anyone else to touch me, but there were always many boys or men around me at different stages of my life.

As a child, I always did what I wanted. I didn't listen much. If my mom told me to put a toy back in its place, I wouldn't do it. Or I would tell her that I'd be outside our apartment building playing, but then I would wander off without letting her know where I'd gone. She never punished me, except for once when I went off into town with my friends without telling her. My mom got scared because I was missing for more than ten hours. She punished me for this, but later she apologized to me because she felt bad for doing it. I was a very active kid; I would often come home with scraped knees from playing outside or falling off my bike. No matter what happened, my mom was always there to love and comfort me to relieve my pain.

Even as a small child, I never got along with Alex, but when I turned 13, I started to have more and more problems with him. As a teenager, I gained the courage to stand up to him. I was growing and becoming a woman, and the issues between us became more and more ridiculous. He wanted to know everything about everyone who was around me and completely control my life to show me that he was in charge. He would comment on my outfits when I went out with my friends to a disco or something. He kept telling me that I would get pregnant, just like my mom.

When I returned from parties, he would smell my hair to see if I'd been smoking and my breath to see if I'd been drinking. It was so ridiculous and humiliating because I was never attracted to alcohol, drugs, or cigarettes. I never wanted those things. My mom never got involved in our disputes because she wanted to avoid conflict at home. Alex was looking for a reason to fight with me. I saw this as trying to dominate in a physical/sexual way. He was covering his own desires.

When I'd come home from school when I was 15 or 16, he would ask me everything about my day; he wanted to know all the details of my life. This only made our conflicts worse because as I got older, I started to talk back to him. I learned how to make him look foolish. This made him angrier because he wanted to show me who the boss was. We had a loving family, but he was not part of it. He was somehow always outside of our love. I was happy whenever I could be outside of the house—at school, with friends—anywhere but home. When I was at home, we stayed in different rooms most of the time and never spoke.

One of his gangster friends, who lived with us for a while, said that Alex was sexually attracted to me when I started to develop into a sexy girl around the age of 14. Fighting with me became a way to compensate for his sexual energy, so I decided it was better to fight with him. His friends would flirt with me and say how attractive I was. They talked to me directly. They never tried anything, but I learned to enjoy the power that my sexuality gave me. I always felt that Alex wanted to have me, but he realized he couldn't, so he took it out in aggression. His way of fighting changed, and he screamed louder. I felt he was hiding something.

Everyone called me 'jailbait' because I was an attractive
teenager. Despite his sexual feelings for me, Alex never tried
anything because we were never close. As I got older, though, he did
start to say how pretty I was.

I was not surprised by Alex's aggression because, as a teenager,
I had a lot of sexual energy. I was very attractive, even though I
lacked sexual experience. Alex also had a lot of sexual energy, and
he was very manipulative and possessive. I had to learn to be the
same; when you live in toxic conditions, you either adapt to them or
become the opposite. I learned from Alex and not my mom. My mom
was in the middle of this, and she was being manipulated. She is a
pure woman, more submissive. Alex and I never hugged or sat close
to each other. We didn't go anywhere together. We lived more like
neighbors, but in the same apartment. Ever since I was 14, this
conflict with Alex made me want to leave home. Once I turned 18, I
learned where it all came from. I preferred our conflicts to sexual
abuse. I can honestly say that I never experienced sexual abuse.
Anything I did sexually in my life, I allowed to happen of my own
free will. Sexuality is power, and I learned to use it to my advantage.
It's like a game; it sets the boundaries of who you are. It defines your
personality. I don't misuse it.

After I finished school in the summer, I packed all my things. I
was ready to travel from Prokopviedk to Tomsk. I was very excited
to leave home. I looked forward to my life alone without Alex. To be
responsible for my own decisions and to start to live freely.

The last days at home, there were a lot of conflicts with Alex, but
I didn't care. He wanted to give me advice on my life after I left home,
"Don't get pregnant in your first year, and be like your mom." He
saw life in very dark colors. He wanted me to think that he was the

only one who cared. Nothing he said touched me. Alex tried to manipulate me and my mom's psychological outlook, but I had a different vision for my life. The last night at home, Alex was acting strangely around 5:30 pm. He started to change; it was like he wanted to talk to me about something.

I just wanted to leave, but he was trying to get closer to me and asked me to sit down on the sofa next to him. We never had any normal conversations, like a stepfather and stepdaughter, so this was very strange. He asked how I felt about leaving. I said I would be happy to be away from him. He knew he was losing his power, but at one point, he started to hug me. I thought this was really weird. He asked if I was a virgin. I said yes. He said, "I really want to kiss you there," indicating my vagina. I said no. He said, "What about if I give you money or buy you something?" I categorically rejected him.

Strangely, I wasn't shocked by this. I just smiled; I knew that wasn't going to happen. It confirmed what I had thought all along, that his aggression toward me was just a mask for his sexual feelings. He wanted to have sex with me, but he couldn't, so he suppressed those feeling with anger and hostility. I wasn't angry or upset when he said this to me. I just considered that it was better that we'd had conflicts all these years, instead of a situation where I might have been the victim of sexual assault. I have learned that often conflict and aggression hide sexual tension. This is a normal human tendency.

My mom came home later that evening. We didn't say anything about what had happened.

I learned a lot from all of this. I discovered that when a girl or a guy starts to fight with me for no reason, it's usually because of their

sexual attraction to me. When a girl starts fighting with me for no reason, I just go up to her and ask if she wants to kiss me. Sometimes, when I reject a man who wants a relationship with me, I notice that he starts to become aggressive toward me. The realization of this connection between sexuality and aggression has helped me in life. I never respond to such aggression.

Off to University

When I woke up the next morning, Alex drove my mom and me to Tomsk, about a 6-hour drive. When we finally arrived at the university, I took my things from the car and said goodbye. It was hard for my mom. She would miss me, but I was so happy to leave Alex. I had worked hard to earn my free education, and I did it all on my own. I had studied hard to pass the exams with high marks. There were only so many places for full scholarships — 4 places out of 200. Alex always offered to pay for university. He wanted to send me to school in Paris, but I did not want to accept his offer. If I had, I would have remained under his control, and this was precisely what I didn't want. Even if I had not earned it, I would not have gone to university in Paris. I had my mind focused on the prize.

I was thrilled when the school year started, but I was also very disappointed. The type of education was very old-style, and they treated us like children. Most students were sheep — they just followed the system and didn't think for themselves. They had no opinions, ambitions, or dreams. University was a little bit like the army. I expected to be treated more like an adult, but we were treated like conformist children. I was kind of alone at the beginning. The others all functioned in a group. I never fit in with the group in high school or here. I was stereotyped because I was pretty. I would usually hang out with older girls and guys, juniors and seniors, or people who had already graduated.

I didn't have too many friends, and I started to look for a job. I began working as a cleaning lady for an IT company near the university. I would go there twice a week to clean the offices when it was closed in the evening. I also applied to the university employment office and got a job handing out political flyers one or two days a week for a couple of hours a day, but I didn't care about the party or the message. I also sold school supplies at a shop near the university. Also, I received a stipend from the university. Because I always managed to find jobs, I never had a problem with money while I was studying there.

There were twenty people in my group, both boys and girls. The boys were military translators and very disciplined because they were in the army. I would visit them and go for dinner or to watch a movie. I didn't like most of my classmates, male or female. Most of them wanted to be the teacher's pets. They were not motivated to deal with real life. Their idea of fun was to go to the disco every week, but I was different — I wanted to learn about life and people, and to make money. University after the first week was of no use to me; I saw it merely as somewhere to live and a salary. My relationship with teachers was the total opposite of high school: history, French, and Russian language. I disagreed with everyone and everything around me. I wanted to get out, and I sought a radical solution. It was a waste of my time. I often went to the director of the faculty to discuss the way I was being treated. I was disillusioned, but I maintained high grades to sustain my scholarship. This was also good for my ego — people thought I was stupid, so I had to disprove that.

However, I was someone who believed in hope, so I didn't pay much attention to studying, but remained very active in sports and

participated in competitions. I always felt like I was among strangers; I had pals and real friends that I went out with, but I never felt like I belonged. It didn't bother me because I was used to that, and my life was so full of activities that I didn't think about it.

When I got to university, I still wrote as I heard, just as I did in the gymnasium. I was really inspired by some of my teachers and just wanted to study and attend university because I felt that there would be some kind of new world for me there. But once I got there, I was so disappointed; the teachers were narrow-minded. They were very conservative, and they always tried to brainwash us. This kind of education did not bring us to new levels or show us ways to be truly rich and successful. They only wanted to educate us to be the same kind of people as they were, trying to make us into little robots. I always felt that they were teaching us to be losers, and this is why I wasn't sorry that I didn't finish university. Also, I always hoped that there would be an opportunity to leave the university — to escape and go in a different direction. What I truly wanted was to be able to express myself and fix my sexual life.

I left the city where I grew up and went to university to study. I had some beautiful illusions; I felt that by changing my environment, my life was going to change as well. I hoped that this would happen because growing up, I felt disconnected from society. Even though my life was full of many activities, I never felt as if I was truly understood. I never stayed indoors much; I had playmates, and I participated in sporting activities. However, I also paid attention to my studies because I believed that going to school would make me successful.

I used to think that university would be different because people would be more grown-up, rational, and practical, but when I got

there, I realized that they were the same kids all over again. They looked at me differently, wondered why I was so pretty, and had a lot of things going for me all at once — I just felt like I was once again in society. I tried to look for some friends without much luck, and I was more focused on money because I was disappointed with the system of education. A few people got my attention, and we would talk, but they were not soulmates to me.

So, for the three years I spent at the university, I didn't have any close friends; I just had people who were near me or wanted to get in touch with me. I didn't hate the people that were not close to me, I always smiled at them, and I was never in conflict with any of them until they hurt my pride or self-respect.

I once had an awful experience at the university residence. It was during the winter, and I wanted to buy something from a shop close by, but it was snowing. There was a kitten out there in the snow; I couldn't leave it out there, so I took it into the residence. Animals were forbidden in the residence, and anyone who brought them in would be kicked out. My kitten stayed with me for about three or four months before it was discovered. I lived with other girls who were older than me, and they didn't care that I had a kitten. However, there was a girl who lived in the room opposite mine, who was younger and aggressive for no apparent reason.

All my life, I have had girls who were aggressive towards me for no reason. Because they couldn't find a way to be in my company, they expressed aggression towards me as a means to compensate for the sympathy they didn't get from me. I understood this, but I always tried to distance myself from it.

This girl, Anastasia, was very aggressive towards me, but I tried to stay away from her aggression. One day, my kitten ran into her

room because her door was open, and it was curious. Anastasia jumped into the corridor and then back into her room. Grabbing the kitten, she flung it like it was a toy into the corridor, and I was just hoping that it wouldn't land on its head and die. Luckily, the kitten landed on its feet without being hurt. I picked it up, went over to her room, and yelled at her. She came at me, and we began to fight in her room. This was the first time I'd fought another girl since I'd been a child, and she beat me. She was sitting on me, and she said that she had dealt with me. I thought to myself, *oh my God, this is something new*!

I have always told people that they couldn't touch my pride and that they had to earn my respect. I realized that I was a grown woman, and I was not supposed to be getting into fights like a child. Still, it was already too late because the other residents had called the police. We both had to write a report about the incident and were thrown out of the residence for breaking the rules. I found this unfair because there were just too many rules to keep, and from that moment on, I wanted to look for a job.

I started to feel that I wasn't welcome in the university or in the city, and I wanted a way of escape. I was 19 years old, and it was my second year, but I wasn't really in love with education and people. I was there so that I could get a job and have a way to make money. I wasn't looking for friends either because I believe all things are temporary, and I was only looking for a way to keep myself busy.

At first, I had been excited to be a student at university and very happy, but time was passing, and my biological clock was ticking. I was 19 and still a virgin! I needed to have sex! All my life, I had been searching for my Prince Charming. I thought I would find him, get married, have a family, and live happily ever after. But my prince

never came along. I finally decided that I would have sex with the first good-looking guy that I liked in the student dormitories. There were a lot of guys and girls who paid attention to me because I was very pretty and I always dressed elegantly in heels, skirts, and dresses. As I spent more time at the university, I decided it might not be a good idea to have sex with someone from there. I finally decided on a guy who had been trying to date me. He was handsome, over six feet tall, with dark hair and blue eyes. I was 19, and he was 22—a mix of Russian and Japanese—he was very exotic-looking, and a very sweet boy. He was a professional martial arts fighter. There was nothing romantic about our relationship, as my goal was to lose my virginity. I told him I had never had sex before and asked him if he wanted to be my first. We each lived in dorms with our roommates. He arranged for his roommates to leave the room so we could be alone.

I arrived at the appointed time. I looked forward to losing my virginity. I was stressed and worried about the pain, as everyone had told me the first time would be very painful. But he was really gentle with me and did his best to teach me. Once he entered me, it took a long time for him to actually penetrate me. Nothing broke! Finally, he got inside me, and I was in such pain! I was bleeding! I thought, *is this what sex is? Oh, my God!* When we finished, I left. The next day, I hurt so much. The guy kept trying to see me again, but I just kept remembering the pain he caused me. I didn't want to see him anymore, but I was happy I'd lost my virginity!

I was excited to look for another job. I worked in a café, making coffee and tea in the evenings. I wasn't in love with the university anymore. It was too traditional, and it just didn't suit me. I didn't think it was practical for me to stay there. I kept going, though, until

I figured out what to do with my life. I kept looking for a job and a way to make more money. For the time being, though, the university paid my tuition, so I stayed. Studies were not fun because the teachers didn't inspire me.

I was focused on making money — and on my sex life! I went on some dating sites because I was horny and wanted to have sex without any commitments. I didn't know what I wanted to do with my life; I just wanted to enjoy new experiences. I was very hypersexual, but I didn't want to be called a nymphomaniac.

A nymphomaniac does not have sex to make herself happy; it's about quantity, not quality. A nymphomaniac has sex to fill an emptiness or a void in her life. For me, sex is about pleasure — to give and receive pleasure. Hypersexuality is very different; it's all about quality and enjoyment. I would always look at teachers and other students, wondering if I would have sex with them or not. I began looking at the world through the prism of sexuality, so I tried a dating website so I could have sex with people outside of the university environment to avoid gossip. I had some good experiences. Guys would treat me well, and so did girls. But I quickly lost interest in them; I was interested in my freedom and life experiences, and I wasn't looking for a relationship.

The manager at the IT company started flirting with me after three or four months. I rejected him. He fired me. So, I began to look for another job right away.

I then decided to look for a different job. I went to an online magazine where people advertised jobs. A very upscale gentleman's club in Tomsk was advertising for waitresses. I was hired immediately and worked there for about four days. There were lots of different drinks, and I had to learn them all, although I had no

interest in drinking. They thought I was too sweet and innocent, so they said I should wear high heels and a mini-skirt. For three days, I dressed like that; then, on the fourth day, they gave me 'stripper' shoes to wear. I made a lot of tips! However, I decided that I could not work so late at night as it messed up my class schedule, and I couldn't study. During my time at the club, I enjoyed watching the girls dancing. Many of the clients asked me for private dances, so the manager then announced that the waitresses would do lap dances, and he offered private dancing. I thought this was wrong because I was a waitress and not a dancer. I made $300-$400 per night in tips. Sometimes I mixed up drink orders, but they didn't ask me to fix them.

I didn't want to do any dancing. On the third day, wearing my stripper shoes, I was carrying a tray full of drinks. I tripped, and the tray went crashing down. All the expensive drinks fell to the floor. Thankfully, one of the guests paid for them, so I didn't have to.

On the fourth day, I opened the menu and read, "Private dancing with the waitress." I didn't like that and thought it was disrespectful. Drunken men started asking me for private dances, but I rejected their offers. The manager came to me and was very angry, so I quit on the spot and left.

I couldn't enter the dorm between 1 am and 6 am, so I went to a cheap café. I had to wait from 4 am until the dorm opened.

All in all, working there was a good experience. I learned that a job in service was not for me. I didn't want to be always available to people and see their visions of life, how they worked and thought. I worked at another restaurant near the dorm for three days. I had to learn all the ingredients for the dishes on the menu, so I rejected this idea and left. I didn't want people touching me because I always

liked to be in charge. The university continued to bore me, and I knew this was not for me. I was always looking for easy ways to make money. I looked for another type of job, then one day, as I was walking down the street, I came across an ad for webcam models. It said you needed to speak basic English and have some skills on the laptop. I called the number and went for an interview.

A few months later, I was walking down the street when I noticed that a guy was following me. His name was Sergei, and he was very handsome. He came up to me and invited me to have a cup of coffee. This was something quite normal for me! At first, I refused, mainly just to see how much he wanted to get to know me, but he persisted, and I accepted his invitation. I always liked to play hard to get.

I liked him, and we started dating, but there was no sex. After a month or so, he asked me, "Valentina, what's wrong? I feel you like kissing me and like to be with me, but why aren't we having sex?" I told him I'd only had one sexual experience, and I didn't like it. I thought maybe I was frigid. I hoped I wasn't a woman who couldn't enjoy sex. I started crying when I told him. He calmed me down, then told me that this was normal. He said that I needed to train my body. I was more afraid of being frigid than having the pain, so we started having sex. It was very painful for me, and I just laid there. Sergei felt guilty; he told me it felt like he was raping me. We tried for seven days. I started to feel less and less pain. At the end of the seven days, I didn't feel pain anymore. After ten days, I began to like it.

The problem for me was that I had very high expectations regarding sex. I was pleased when I started to feel good about it. When I told Sergei, he was thrilled. He explained to me that it was all about training my vaginal muscles. It is so important to have a

partner who cares about your feelings. It is all about communication. I feel sorry for girls who do not have that. Sergei was glad that I had shared my feelings with him. If your partner cares about you, he will care about your orgasm and how you feel. I feel bad for women who never have an orgasm. It is not just about having the right partner. It is also about communication. You have to be open to communicate your feelings, and then you will see if your partner understands this and reacts to it.

I was fortunate to have a mature partner, as I felt that he really cared about me, and he worked hard to prepare me. Once I started to have orgasms, my life changed. I felt immortal. I became more relaxed and easy-going, and I became kinder to people around me. There are always new things to learn about sexuality, and information is readily available. Your sexual life is about your sexual health, and this is no less important than taking vitamins or checking your blood pressure.

Sergei was a good lover. He was only the second guy in my sexual life. He tried to open my sexuality to help me discover my erogenous zones and to discover how to have an orgasm. He would always ask me what I liked as we experimented with different sexual positions. It was almost like a kind of training, and I learned to explore. I was fortunate, as not every girl had this experience in the beginning, and once I started to have orgasms, it gave me more self-confidence. It made me feel complete and secure.

I spent a couple of more months with Sergei. He was a very caring person, and I was grateful that he had helped me. He was my second lover. After half a year, he told me that he was leaving Tomsk to take a job and that we had to break up. I cried and was upset, but

the next day I just accepted the fact that people come and go. So, I forgot about him.

Sergei came back a year later, and he wanted to get together again. I met with him for coffee. I looked at him. He was handsome, and I liked him, but I felt nothing. I realized that I could not take back someone who dumped me even once. The feeling of love had disappeared. I feel that same way today. He explained he had to leave to make money. I told him I was flying to St. Petersburg to make porn movies. He was very sad. But I wasn't ready for a relationship. He told me that one day I would fall in love, and the other person would reject me, and then I would know how he felt. It sounded to me like a curse. I was always a little superstitious. I laughed, though, and said, "Yes, but it will be a woman, not a man."

Sergei left, and I never saw him again. So far, I haven't ever loved another person who rejected me. Almost ten years have passed, and my sex life is better than it ever was. I thank Sergei for helping me with my sexual education and discovering myself. I learned to have orgasms, and I became brave enough to start dating girls. I didn't want to date a girl from the university, as most of the girls didn't understand their sexuality.

I decided to go to a dating website and started to search for a girl. After a lot of searching, I found Irina. I think I should say something here about what Irina, my first girl, looked like. She was 25 years old, a little bit taller than me, she had blue eyes and short black hair, and her boobs were bigger than mine. My favorite things about her were her lips (they were very sensual and perfect to kiss) and the contrast of her black hair to her blue eyes. She was very gentle and feminine, which was why I chose her. I have never had a thing for girls who are masculine and lesbian; I only like girls who

are into other girls and guys. It was very important to me that she was bisexual because I didn't want someone to fall in love with me, and I just wanted to enjoy myself.

She was married and looking for a girl to have fun with. We agreed to meet for coffee. We met at the same shop near the university where I used to meet Sergei.

The next day her boyfriend came to pick me up, and he took me to her apartment, where I then had my first girl-girl experience. It wasn't awkward at all. It felt natural. I felt like I was born to have sex, to give pleasure, and to receive pleasure back. When I have sex with girls, I feel like they are part of me. I was so happy. I was glad to give her pleasure and happy for myself. I didn't tell her she was my first. I felt like this was a new period in my life. I wanted to learn more about sex — to enjoy it. I delved into my sexual life further, as studying at the university did not satisfy my needs.

Irina was a great lover; she was very communicative and told me what she liked and didn't like. I was glad that she wasn't from the university or a roommate or something like that, because I wanted to keep my private life for myself. Happiness loves silence. After Irina, I decided I wanted to have more experiences.

Working as a Webcam Model

I felt like an outsider. I had a few friends, but no one very close. I had no real emotional attachments. I wasn't very attached to my job, either. I just wanted to make money, and it seemed like a sex job would suit me best. I believe that if you really want something, you will get it.

I started to write a book in October 2012, but I had no publisher. I rediscovered some of the text from it, but I gave up on the project.

I want to explain how I got into sex work. One day I was on my way to work at my cleaning job, I saw a paper on the street with an announcement that they were looking for webcam models. This seemed interesting to me, so I called the number on the paper. About a half-hour later, a guy came to my dormitory. He picked me up, and I went with him to the webcam studio. He wanted to show me what the studio looked like and how it worked. I told him I knew nothing about it and I didn't speak English. He said not to worry, that he just wanted to show me around.

When we arrived at the address, we entered a simple apartment building. The studio was in a typical apartment with three rooms and a kitchen; the living room had a computer and a sofa. The kitchen was also used as a workspace. It looked like a standard webcam studio in Russia. The owner of the studio, an older Russian guy, was there. The first thing he said to me was to ask me for my passport. He couldn't believe I was 18. Actually, I was 19 already,

but I looked more like 16. I was petite and skinny, but I think it was because of my face that people thought I was so young.

We discussed the possibility of my beginning work as a webcam model the next day, so the following day after school, I took a bus and went to the studio. The owner's name was Ivan. He opened the door and explained to me how things worked. He told me this was not a job for me; I looked too sweet and innocent for this type of work. He said that most users prefer girls who look sluttier and have more experience. He said I looked like a 'girl next door.' He said that I could try, but he didn't think I would have much success. I wanted to prove to him that he was wrong!

He left the room, and I started to do an erotic chat. I had no experience and had never seen a chat done before. I had trouble figuring out how it worked. But I pushed the button and waited for users to invite me to a private chat, which is where you make money. The biggest problem was that I didn't speak any English. My English teacher in school had been very young, and I didn't really learn much from her. I knew no English, so I mainly worked in Russian chatrooms. I wasn't very good at typing either. But after four hours in front of the computer, I made pretty good money. I was very happy, and I wasn't tired at all. It didn't seem like work. I was in charge, and I loved it. When I counted my money after those four hours, I had made as much as I did during an entire week at my regular cleaning job.

At the end of the shift, Ivan returned to count the money. He was shocked to see that I had made more than the other models. I was delighted that I had proved myself. I had shown that power comes from within; it is not physical. I felt like a winner! From that day, I

worked each evening in the studio after I had finished my studies. I gave up all my other jobs and had more time for my private life.

My days started to have more structure. In the morning, I went to university. I finished around 2 pm and then went to the webcam studio. After 4 hours or so, I would go out in the evening with some of the guys or girls. Then I would return to the dormitory to do my studies. I was very happy. I felt fulfilled sexually, and I felt really good being around the people I worked with. I just felt really close to them, we had fun, and I didn't have to hide anything from them. I felt like I was in the right place, and I could speak freely. For the first time, I felt like I was in the right place with the right people. I could feel safe and open.

I tried to improve myself and my love-making skills. I used dating apps to meet guys and girls for romantic evenings. I was never looking for attachment; I was just hungry for sexual experience. I always treated people with respect, but I never wanted to enter into a committed relationship. I wanted to enjoy life and to seek new experiences and emotions.

After Sergei and Irina, all my lovers were good looking and sensual guys and girls. I wanted masculine guys and feminine girls. Once I get a lover, I start to improve myself by searching for more sexual experience. Mostly I used dating sites, and it was not usually a love story; it was all about dates, romantic evenings, and sex. And after that, I would disappear. I have never felt the desire to be attached to a person; I was just curious and hungry for more sexual experiences. It gave me a sort of emotional joy, and it felt like changing toys. I always treated people with respect, but I have never wanted to stay with one.

I don't leave out of fear; I leave because I have so many possibilities to explore, and I am always looking forward to something new. I remember dating a pizza guy, and I liked him enough for sex. So, we went over to his apartment, had sex, and slept; then I woke up at 5 am, took my coat, and left. He didn't know when I left or where I had gone. The sex was good, but I didn't want to get attached to any of these guys, and I didn't feel like breaking their hearts. I wanted them to treat it like a pleasure ride or a one-night stand, but I never told them that because I didn't want them to treat *me* like a one-night stand! I always want them to treat me with a lot of respect and passion. There were a lot of guys and girls. Still, I always left because I knew that I had no plans to stay in Tomsk forever, and I was even looking for a possibility to escape university.

This was why I didn't want someone hoping and waiting for me, only to be disappointed. I didn't want to treat people as if they were not important. I didn't want my lovers thinking about me and trying to come back to me, but at the same time, I didn't want to hurt their feelings. I just wanted to get and give pleasure. Back then, I didn't realize that it was possible to communicate with people and tell them how you wanted things. And maybe it wasn't right to leave them in the middle of the night and never give a phone number; after all, I was dating good people.

After that, I moved to Europe, and there wasn't much change because I kept running my sexual life and money-making process. When I was in Tomsk, I was just ambitious about making money and having a colorful sexual life. I remember that I wanted more sexual work, but I couldn't go back to a gentlemen's club because I had realized that club work wasn't for me. I knew that I didn't want strangers touching me without my permission, and I didn't want to

do escort or prostitution work. I started searching the internet for more sexual jobs. I wanted to totally give up on university because I had lost respect for the institution. It was unfair that I was badly treated when I had the kitten incident with Anastasia, and I was kicked out of the dorm. It was unfair that they didn't consider whether you had somewhere to go to or whether you had money to rent an apartment before kicking you out of the dormitory.

When I started to work at the webcam studio, I gave up my other jobs. I was making enough money so I could begin to have some free time and pay attention to my sexual life. It gave me financial freedom. I used to meet with different boys and girls, not always for sex, but just to talk. I would meet people of different ages and backgrounds, from students all the way up to parliament deputies. I liked meeting smart and interesting people and learning from successful people. I loved to flirt. I enjoyed it more than the sex itself. I liked to play games and provoke people. It was important to me that men looked at me, not just as a cute baby girl, but to appreciate me as a person. I was often close to people but inaccessible at the same time. I liked to see people look at me with desire, and I was very manipulative. I loved to tease!

I met with many different people during this time, as I didn't want to limit my options. Each person had good and bad points. I noticed that people would fall in love with me easily. Still, I didn't want to become attached either emotionally or materially, and they were always very disappointed that they could not have me for themselves.

While working at the studio, I noticed that the other girls there were the kind of people I enjoyed being around. They treated the job like a hobby. They were easy to talk to and open about sex, but they

weren't slutty. Most of them were students like me. I really enjoyed talking to people on webcam. I didn't know much English at the time, so I mainly worked on the Russian webcam site. One of them was called Russcam and the other, Video Girl. I was happy because many guys came to my chatroom. They gave me tips and told me how pretty I was. I started to get regular customers. I felt like sex work was the most interesting type of job for me. I had finally found the right job for myself.

I started to learn a lot more about men, both young and old. Many of them just wanted to talk. I began to understand how lonely people were, and they just wanted someone to bring a little joy to their lives. I liked that it was online. My biggest problem was that I didn't speak English. I also worked on an American site, My Free Cams. I tried to use Google Translate, but it didn't really work. So, the men on the American site mainly just had to watch me. Many of the men just wanted to talk to me, even if only online. Not all of them had any sexual interest in me. There was such a variety of people that I learned about life through the prism of sexuality. Customers on webchat are not just looking for sexual satisfaction; many people are lonely and only looking for a friend or someone to talk to. Some people need someone to confide in and tell their problems to. This kind of work made me realize how many lonely people there are in the world. They often feel they can be more open by talking to a sex worker than to family or friends. Sexual topics are often taboo, but they feel free to discuss these things with a sex worker, subjects that they couldn't talk about with other people.

No one judged anyone. Customers just gave us tips. I was very confident, and self-confidence puts you in a stronger position. I learned that not all men are perverts. The girls at the studio were also

easier for me to relate to and get along with than the girls I knew from university or my other jobs. They were very friendly, and I really felt like we were a team. We had a lot of empathy for each other. We would visit after work or during breaks. We had a great time together. It was very cool. Sometimes we made custom videos together, kissing and touching. It was a lot of fun

As webcam girls, we often got offers for escort services, but none of us ever accepted these. Sometimes they offered crazy amounts of money for sexual services. Still, it was just not something we were interested in doing. To avoid people from recognizing me on the street, I would block out my region on the webcam site, so I was only talking to guys who lived far away from me. I would also use the name Marina to further hide my identity, and my webcam nickname was 'Dirty Thoughts.' Ivan, the owner of the webcam studio, gave me the nickname after looking at me.

I never did escort work. Yes, I love money, and I am a material person, but I never had the desire to make money in this way. I love art. Webcam work was always art to me, just as porn would become for me. Escort work and prostitution are different. I find it regrettable that many people equate sex work with prostitution when they are really two separate things.

Here I continue my story about webcam and how I got into porn. Things were pretty good for me—I had a good job on webcam, and I was attending university. I had the money for my schooling and a good sexual life without any responsibility. But, after I had worked with webcam for about two and a half years, I felt something was off, like it was too much of a routine, and I needed something new. I started having communication issues with people on the job. I also had problems with Ivan, my boss, because I was redirecting

customers to my Skype account and making extra money while still doing webcam chats. When he found out, I did not try to hide it. I didn't feel like I was stealing money from him. I was just doing extra work from my own customers, everything was fine with me, but webcam work started to become less appealing. Doing the same thing every day made it less fun, so I began to look for a change.

How I Got Started in Porn

Around the end of March, I was in the webcam studio, and a Russian guy who I didn't know started chatting with me. He mentioned his name and said that he was scouting for girls who were interested in filming porn. At first, I thought he was joking. I was a little shocked, so I told him that I wasn't interested and ignored him because I didn't believe that anyone would offer me porn for real. I thought it only got offered to American girls, but I was curious, and I began to talk with him. I didn't know they shot porn in Russia and Europe. I thought they only shot porn in America. He said he liked me because I was very pretty and playful, and in a couple of days, he made me an offer. I asked questions about the shooting, the location, accommodation, and money, and he explained that they took care of everything, including health.

The place, story, and salary were great, there would be blood tests before every performance, and the shooting location was St. Petersburg. But I was attending university, which was like being in kindergarten or the army! I had to show up every day, or there would be problems with the principal and professors. So, I told the guy that it would be better for me to come during the summer after my exams, and he said that would be okay. It was not difficult for me, I could have waited to finish my third year and go the full course, but it didn't happen like that.

This guy was a scout for one of the porn studios in St. Petersburg, and he lived in Moscow. He started texting, just to check up on me and make sure that I was still agreeable to do porn. He asked a lot of personal questions, which I found pushy, and I told him so. He said that it wasn't a problem and that he could give me the contact of the girl who was the manager of the porn studio.

She handled the organization of the shoots, and I could ask her about the details because I would eventually meet her in St. Petersburg. I said okay and added her to my Skype contacts that same evening. Her name was Nadia, and she lived in St. Petersburg. She was really the manager, and she took care of everything; male actors, female actors, locations, everything. She was quite polite when we started chatting, and she quickly answered all my questions. This made me trust her because I felt like she knew what she was talking about. She asked for my photos to set up a profile for me, so I sent her a few. She said that they had lots of jobs for me, but I told her that I could only come during the summer, and she said that would be okay.

After a few days, I asked her about the kind of jobs they could offer me, the number of shootings that came with the job, and the minimum I could do for 10 days. The more information she gave me, the more excited I became! This was like a childhood dream come true because I always loved to watch porn. The first time I saw porn, I was about 10 years old; I had DVDs for my cartoons, and one day I slotted one into the player, thinking that it was a cartoon. I soon realized that it was a porn movie that belonged to my stepfather. It was a guy having sex with a girl, but I saw how beautiful her face was as she got pleasure. Her facial expressions captivated me. I remember that, and I have always watched porn, so I was happy to

try it. For me, it wasn't really about the money. I looked at it as an adventure; I would just go, shoot, and come back to my normal life. I just couldn't wait to start the journey!

I told Nadia that I would talk to a friend of mine who worked in a private hospital who could help me get a fake medical certificate that I could use to excuse myself from school. One of my guests on video chat who used a fake IP address told me that he was a doctor, so I contacted him for it, and it worked!

Nadia asked which day was good for me to fly, and she bought me a ticket within the hour. At first, I wanted to wait until summer, but I wasn't really committed to attending university, and I wanted to do it now because I was really excited about it. The next morning at about 6 am, my friend came to my place and took me to the airport. It was my first time flying anywhere. My flight was for 8 am. Nobody knew where I was going, except my friend who brought the medical report. I only took my passport and notebook with me for the flight to St. Petersburg. I had to wait for a couple of hours, so I called my mom and told her that I was in Moscow. I didn't know why I did this, because I had lied about where I was going and why I was going there!

When I got to the airport in Moscow, I tried to call Nadia because I wanted to be sure that there would be someone waiting for me, but she didn't pick up. I was worried because I was five hours by air away from home, and nobody had talked to me. I decided that it was a connection problem with the phone, and I took my flight from Moscow to St. Petersburg.

On the flight, I met a guy who said that if nobody picked me up in St. Petersburg, he was going to pay for my flight back. He was a businessman and was just casually flirting with me on the trip.

However, I didn't want to go back; I wanted to move forward. As soon as we landed in St. Petersburg, Nadia called, asked for my whereabouts, and apologized for not picking up earlier. She said that she had sent a taxi for me, and she gave me the taxi number. As soon as I got out of the airport, it was waiting. This was my first meeting with her. Nadia was a 27-year-old Russian girl with long brunette hair and a little shorter than me. She was very calm and friendly, and she was ready to answer all the questions that I threw at her. We went to a Japanese restaurant to eat and discuss business.

After that, we went to the studio; it was a huge apartment with four rooms, a kitchen, and a bathroom. Two of the rooms were for shooting; the models slept in one, and the last one was for actors who worked permanently for the studio. Makeup was done in the kitchen with special equipment. Nadia and George, who was her boyfriend and the producer, drove me to another studio for a casting photo. I decided to come back on my own, so I chose to walk because it was my first time in St. Petersburg; I was free of any plans, so I decided to explore. But, at the end of the day, I realized that I had left my phone in the studio, I didn't have any money on me, and nobody had a way of contacting me. It was already evening, and everybody was worried; George, the producer, and Nadia, his assistant.

I realized that I didn't know the street. Our location was on a perpendicular street, but there was more than one of those. However, before the sun went down, I found the right one because even though I didn't know the name of the street, I remembered what the house looked like. And by some magic, I found the building, and everything was fine. They were really worried that something terrible had happened to me. They were very worried, as it was my first time in a big city, but I felt brave in a silly way.

Still, it was normal for me to take off without letting others know where I was going. I just felt that I was always free to do whatever I wanted to do. Everyone thought that I was lost, but to me, I was only exploring. And I always found my way home.

The next day, I took a blood test for HIV, hepatitis B, syphilis, chlamydia, gonorrhea, etc. Everything was fine, and that day, we started to work. I got my first makeup to get ready for a porn video — a lesbian scene. It was not really my style — the scene was without kissing, touching, or any intimate contact. My partner and I just tried to play the story for each other.

Both of us were uncomfortable because it was so unnatural, and I felt that this wasn't something that I could do every day. It was the most brutal lesbian scene that I'd ever done because we could not express ourselves and had to perform with no emotion or passion; it was all character. We played it in a brutal way; it was very forced, and it was just humiliating. I wanted to do my best, but I had no experience, so I used my sexual instincts. The other girl was also new, and it felt like she had no desire to be with a girl, so I had to take the lead. She was not very communicative, and I had to put her in the position. There was no emotion involved, nothing tender or romantic. Our makeup was too much and too vulgar, but this was my first porn scene, and I was excited to learn and improve. I think the other girl was just in it for the money. We had to use sex toys that we had never seen or used before. Everything went smoothly; I remember that we shot one scene into the evening because the other girls and I were new. We didn't know how to pose for the teasing photos, and we could only get one scene done that day. I also felt that my partner was new, but she wasn't like me — she didn't look as though she fit the part. I felt like I was raping her, and neither of us

liked the makeup because it made us look cheap. But honestly, when I was working for that company, there was only one style of makeup for almost every shoot. It was funny because I had the kind of face that didn't need so much makeup. I didn't like the way they were putting all the makeup on me or the way they were dressing me, but it was interesting to me. At that time, my primary interests were sex and money; I didn't plan on building a career in porn; I only wanted to try it. The money I was going to make for two weeks' work was a lot because I was just a student then, and I was living in the studio. I had a few days off, which was why I decided to take a walk around St. Petersburg. I was amazed by the beauty and size of the city — they had a metro, which we didn't have in Tomsk.

During the two weeks that I stayed in George's studio, the scenes were totally hardcore and gang bangs. However, when I saw the video, it looked so brutal. I was shocked because it seemed too hardcore, with five men trying to destroy one little girl. It was amazing how the video changed reality. I liked the group scenes because they were completely different. I realized that when a lot of guys were involved, they were sweet and gentle. They were a bit nervous, and they treated me well, even though it was hardcore. Of course, people watching the movies would think that I wasn't going to survive, but it was different backstage because we laughed over everything. The thing I like most about the industry is the friendly atmosphere and how well the performers treat each other. I have never seen strangers care and give helpful advice like that in my life. I remember that my first video lasted 40 minutes, and the guys were always thinking their actions through and asking if I was comfortable.

In general, I didn't care about what people thought, and I wanted to shoot more and more. I spent a total of 21 days in St. Petersburg; I'd wake up, shower, go to the studio, and the makeup artist would come to make me up. Then I would usually eat breakfast with Nadia. The company paid so much attention to me, and I felt that they wanted me to stay. They suggested making me a porn star and sending me to go to work somewhere in Europe. I didn't take them seriously because I just wanted to do a few videos and get back to university, as I had promised my mom I would finish university.

Nadia and George seemed as if they had taken a personal liking to me. At first, I thought it was because George wanted to make a lot of money off me, as he was always smiling at me. He wasn't coming at me sexually, but I couldn't say the same for Nadia. Sometimes I'd catch her looking at me, and sometimes she'd try to tease me in a friendly but strange way, and sometimes she would touch me. At some point, she showed me a photo of her ex-girlfriend and told me that she liked blondes. I wasn't a blonde then, but I looked more blonde than brunette. She more or less let me know that she enjoyed sex with women. I took it all as a game without responsibilities or obligations − to me, it was just flirting. It also made me more comfortable because even though we were making porn, I felt I could trust them.

I was always first to start the photoshoots, and Nadia was constantly around to see. It looked like she enjoyed the situation; it made her horny, and she didn't try to hide it. Nadia told me one day that she liked the scene, and she wanted to be in my place. I found it odd because I was just doing my job; she was sort of my boss, and also George's girlfriend. And so, I felt that they were both trying to drag me into some kind of personal adventure.

I remember that I wanted Nadia, and it was distracting me from my job. Before we began filming my first BDSM scene, I was in the studio with just the camera guy and another actor, and I was emotionally stressed. Although I knew that it was all a game and that I could back out at any time. The thought of someone coming at me aggressively while my hands were bound was just terrible.

When I worked for George at the first studio in St. Petersburg, I was offered a job to make 10-15 videos during three weeks. I was made up to look as young as possible. I liked the actor I worked with, and I trusted him. I had to pretend I was scared, and the guy would come and be brutal and dominate me. It was all play for the film, and after the domination, we would have sex. It was uncomfortable, as it was not my style. They put me in a cage and tied my arms and legs. He used some toys and wore a mask and BDSM clothing. I knew he wouldn't hurt me, but I just didn't like the scene. I had to cry to play the character, but I cried real tears as I just didn't like anything about the domination stuff. After I calmed down, we moved on to the sex part, which was fine. I understood that I couldn't play the victim role, and I decided never to do a scene like that again. I took it seriously, and I didn't like the idea of domination, so I told them that I didn't want to do that again. I remember feeling worried, afraid, and victimized, and we were only at the beginning of the video! It became clear to me that I did not like being submissive, even in a film.

I realized that because of my sexuality, I was not the kind of girl it was possible to dominate because I kept on fighting. They were telling me, "Hey, Valentina, play the victim." It was emotionally frustrating. Then the sex started, and everything was fine. As usual, the guys tried to look tough on camera, but they were being gentle

with everything. That allowed me to trust them when the sexual contact started; it was the game before the sex that I really hated. But I let it happen, and it was a lesson for me to never again accept that kind of shoot. We were finished in 40 minutes, and everybody left. I stayed in the studio with the other models who were also living there for free.

The next day was my day off, and Nadia called to ask if I wanted to go shopping with her and George. I agreed because I had nothing to do, and I was happy that she wanted to show me around. Later, George made dinner, we ate, and we moved to the living room. I didn't know whether it was their thing as a couple to bring girls home because George didn't even try to join us, and after a few minutes, he left to go sleep in another room. Later, after snuggling with Nadia on the sofa for a while, I left when she fell asleep.

Nadia kept texting me on Skype, asking why I left and telling me how sorry she felt when she didn't see me in the morning. I just felt that she needed more love because I wasn't used to having romantic situations with girls. I just go strictly for the sex, so it was unusual for me to be together with someone and not have sex.

At that moment, I felt that I wanted to see her again, so I went to her apartment because I wasn't working that day. Vladimir, George's camera guy, and everybody else was in the studio when I went to see Nadia. When I arrived at the apartment, George was just going out; he knew I was going to spend the whole day with his girlfriend, but it only amused him, and he didn't say anything. I have always been one to enjoy the moment without worrying about the future or the past. In two weeks, I was going back to university.

I called and asked my friend if it was possible to extend my papers by a week, and this request was granted. I got to stay in St.

Petersburg for three weeks, and I stayed with Nadia and George in
their apartment for two days. I was there with George, Nadia, and
another porn actor. They tried to get me to play games, but I refused
and excused myself and made to go to the studio that night.

Then Nadia started saying that it would be a good idea for the
three of us to live together. I was shocked because I wasn't used to
living with one partner — how could I live with two? I was hoping
that it was all a joke, but Nadia said that it was a standard
arrangement, and George agreed. He asked if I would leave
university and come to live in St. Petersburg with them.

The next morning, I left St. Petersburg. Nadia kept texting about
how horrible it was that I had left because she really loved me, but
she couldn't be my girlfriend. I didn't understand any of that; I didn't
know what she wanted because I'd never had a relationship with a
woman. I just wanted to enjoy life, but she started making me think
that I had done something wrong. The morning before I left for the
airport, she came to say goodbye; it was as if nothing had happened
between us because there were many people in the studio. She
looked like she was going to cry. She told me to wait for her because
she had to step out of the studio for a while. But she wasn't back in
an hour, so when the taxi came, I left for the airport. I think she did
it on purpose. However, my time was up, and I had done what I
wanted to do. There had been lots of interesting situations and
emotions. I didn't know what my plans were, but I just followed my
feelings, and I knew that I had to get ready for my exams.

My trip to St. Petersburg was over, and the driver took me to the
airport. All I was thinking about were my exams and getting back to
my normal life because my adventure was finally over. I had already
decided that I had to finish university, even if I did not like it. I flew

from St. Petersburg to Moscow, from Moscow to Novosibirsk and from Novosibirsk to Tomsk, so it was a very long trip. My friend was at the airport in Tomsk to pick me up. This was the same friend who had helped me with the fake medical report and had driven me to the airport when I was leaving. I felt that it was a criminal offense to present the fake report as an excuse for my absence of three weeks to the school, but it was too late to avoid that now.

I went home to get some sleep because I was jetlagged, and I was now in a different time zone. That evening, Nadia sent an email to ask me whether I was angry because she didn't say goodbye. It didn't bother me. The next day, I took the report to the university, and the professors said that it was fake because it was from a private clinic. They didn't like the idea that I was faking the report, but at the same time, they could not prove it. At first, I thought that I would continue my routine, and things would get back to the way they were, but after three or four days, everything changed.

I was studying for my exams in the dormitory one evening. I had borrowed lots of books from the library just to get ready for my exams, but then, I heard a knock on my door, and I went to check it out. It was a faculty friend. I was not close to the guy, we were just on friendly terms, but it was odd for him to come to my room. I let him in, and he gave me a memory card and asked me to check the video that was on it with my computer. He told me that everyone in the residence was currently viewing the video because someone had uploaded it onto the university's local server. The whole university was going to find out by morning, and he advised me to leave the university residence and go to an apartment because the whole thing was going to blow up. He said that he came over to tell me because

we were on good terms and he knew that I didn't know about the video.

I told him that I wasn't going to leave the dormitory because people were prying into my private life and how I made my money. I thanked him for telling me what was going to happen. He left, and I continued my studies. I have always been strong-willed, and if I decided that I didn't care about people's opinions, I just didn't. I was curious because the video had not even been uploaded on the company's website, yet it was on the campus' local site in just about four days. I didn't understand this, but it had already happened, and I had to accept it and move on with my life. People were going to be looking at me and making comments about me, but I was sure that some people would also take my side. About the others, I didn't care.

I decided that I was going to go to school the next day as if nothing had happened. I did, and nothing happened. Within the next two days, I could hear people laughing behind my back and saying things about me. But no one dared to say anything to my face. For the university dormitory, this news was a bombshell because it wasn't just simple porn; it seemed brutal and crazy to them. It was a video of a boy/girl for the First Anal Quest site. He was my age but more experienced. He was passionate but very professional. However, there was nothing romantic about the scene; it was just hard anal sex, with him in control. We had also made some hardcore photos that someone had taken pictures of and posted it online to my high school and university websites.

The video sparked discussions, even outside the university, because someone had uploaded all my personal information to the internet. People were curious about my personality. Whoever uploaded it also sent a link to all my friends and family. That person

went to great lengths to make me famous! Then a teacher who had taught me in the gymnasium called me and told me that someone had hacked the gymnasium website and posted my photos and videos there. All these hardcore videos were on the site for up to three days, and no one could fix it. The next one was my university website — it was hacked, and they put my information up like it was some fantastic news. I didn't know who did it, but it was epic because suddenly everybody knew what I did as an adult film performer.

I hadn't done anything wrong, and I didn't feel sorry for my choices; I just felt that other people should mind their own lives. I felt a little uncomfortable because of the gymnasium website. Kids and parents who wanted to check study schedules just had my asshole staring them in the face. This was not the way I wanted to be remembered, but it had happened, and it was not my fault. People started to call me from Prokopyevsk — my teachers, friends, mates, and everybody called to ask questions. Many blogs were calling me a slut and saying that I had brought shame to my parents, while others supported me. The whole thing was like a conflict, with some people saying that I was a slut who deserved death and others calling me a hero because it wasn't good to be sexually stifled. I didn't react to any of them because I was trying to figure out my next move in life. Honestly, I took it as good PR, because all of a sudden, everything was out in the open. I didn't have to lie anymore — I felt so relieved, and I was even thankful for the whole situation.

People were shocked, but it wasn't about what I had done; it was about who I was and why I did it. I looked like a good girl who did all the right things, and that was what made it a scandal. In their minds, I had broken all the stereotypes. However, nobody faced me

directly to say anything or tell me how I should live my life. Maybe it was because I acted as if nothing had happened. After all, to me, nothing *had* happened.

A week after the leaked video, the dean of my faculty called me in for a meeting. I didn't know why she had called me, but I felt like my stay at the university was coming to an end. I understood that people were very conservative, and these old-school people could not understand my interest in porn. They were also worried about the reputation of the university more than they were about my studentship. She was very calm with me, served me tea, and then she said, "Valentina, we found out about your occupation, and we don't expect that from our students. If you had money problems, you could have come to us because we try to support our budget students." I was one of the budget students were students who went through school for free.

She told me that she had to kick me out of the university on the orders of the rector. However, because she felt sorry for me, she offered me the opportunity to do it on my own terms. That way, I would have the opportunity to continue my studies at another university. She guaranteed that there was no way I was going to pass the exams and that it was best for me to reject my admission. If I didn't, the school was going to go through the courts to prove that I was the person in all the photos and videos. I would be kicked out, and there would be a big scandal. She told me that all the teachers and professors were going to recognize me, so it was going to be impossible to deny it. I would finally be kicked out for immoral conduct and tarnishing the image of the university. She told me that we could fill out the papers right then and that it would be best if I

left the city and go without any scandal to a university in a different city.

She also said, "Valentina, you could say no, but in that case, you would have a really huge problem. I sincerely feel sorry for you." In fact, she just kicked me out of the university because of my private life. I wasn't shocked at what she said, but I was shocked at how easy it was to judge someone based on her sex life. I was shocked at how morally sound she pretended to be whilst trying to act friendly to me; it was so hypocritical. I realized then that I couldn't endure two more years with these people who I didn't respect anymore. I signed the papers, and she said all my documents would be ready in two weeks. It wasn't about what the rector and the rest of the university thought about my actions; I was thinking about my next move. They were going to kick me out of the residence shortly, and I wouldn't have a place to live.

I left her office and met another professor outside; I greeted her, but she didn't respond. However, she proceeded to tell me that I had no moral right to be within the vicinity of the university. It was ridiculous because I only performed sex acts on camera, and everybody was treating me like an immoral person. From this point, I knew that everyone at the university knew my occupation. People don't even understand what moral qualities are about; they simply have mixed feelings. I wasn't even thinking about them. I was thinking about where I was going to live because I would be kicked out of the dormitory soon. But I felt happy that I didn't need to deal with the university anymore, and I was thankful to the person who made news of my adult career public. There is an organized group of people who love to expose Russian girls who do porn, find out their personal information, and let everyone know what they do,

including their families. This causes some of the girls to become addicted to drugs, commit suicide, and alienates them from their families. These people take great pleasure in doing this. However, I became used to social pressure as I had always been against what society thought.

I also felt that my relationship with the webcam studio owner was dying — he was the one that gave me a place to stay for six months when the university kicked me out because of the kitten issue. The questions in my head were: what do I do? Where will I live? What will be my next occupation? What is my next step? What is the best thing I can do for myself now? I wasn't thinking about social opinions at all.

The owner of the webcam studio was already angry with me, and I didn't have any plans to work for him or stay in his studio anymore. I knew that I had to take a new direction, so I just created my own account on the Russian website, and I was more like an independent webcam model. So, I continued doing erotic web chats on my own, and the same friend who helped me with the fake papers helped me rent an apartment for a little while. But I didn't think about staying there permanently because, since I wasn't studying anymore, there was no need for me to remain in Tomsk. This was how I started my first independent business, which was webcam modeling; I started making money without anybody's help. However, I found that I didn't enjoy webcam modeling as much as I used to. I started thinking of moving to St. Petersburg because there were more universities there.

I could apply to any of them, but I would have to pay because, according to the rules in Russia, you can only go through university for free once in your life. Also, there would be more job offers in St.

Petersburg. But it took about a month for my withdrawal papers to be ready, and during that time, I focused on working on webcam, and I frequently checked dating sites. I found a brunette who was about 25 or 26; she had a husband, a lover, and money too. She seemed like someone who was either bored with life or someone who had everything and still wasn't satisfied. She wanted a girl, and I wanted to forget all the bullshit that was happening around me. We chatted for a while and decided to meet; I told her that I was just interested in sex and not dating. We met in her apartment and had sex. Afterward, she asked me about myself.

I didn't want her to fall in love with me, so I just told her that I got kicked out of the university because I did porn. Our relationship lasted for a short period, but she was always interested in me. I didn't like the idea of someone being interested in me just because I did porn, though.

When I got my withdrawal papers from the university, I also got an email from Nadia. She said that if I wanted to do more jobs in St Petersburg, I could go there. I still don't know who released my videos because, at that time, only George and Nadia had access to them.

I remembered everything and how it happened. However, I wasn't interested in talking to George or Nadia about it because I was only concerned with my exams and settling the issues with the university. After everything was settled and I had got my withdrawal papers, I began to wonder how the videos got onto the internet when they weren't even online yet on the website. I texted Nadia and asked her because it looked like she had put it up. She told me that none of them had done it, that they were just producers, and that they had another boss. So, it looked like I wasn't going to

find out who did it, and I didn't try to. They kept on telling me that I could come back because they had lots of shoots and offers for me, and they would be happy to see me in St Petersburg again. I started thinking of going to St Petersburg to apply to a university there so I could shoot porn during the summer for some quick money. But my main goal was getting into the university — shooting porn was to make money for university, rent an apartment, and afterward, see how life went.

So, I told George and Nadia that I was ready to come back, and they booked my flight. I took all my papers from the university, packed my stuff, and left; I had only one piece of luggage. I arrived at the same studio and location in St Petersburg, and I started work. I was more focused on work and money, but Nadia was still communicating with me. The relationship between her and George was horrible. She said that after I left, she started to see him differently, and they fought more. She told me that she wasn't happy with George anymore and that she now had the attention of another Russian guy, Constantin, who was George's partner and boss. I told her that it might be better to go for someone who was paying attention to her, and from her reply, it looked like I pushed her to do it.

Nadia and George's sex life, and life in general, wasn't good, but they kept trying to make it work. However, Nadia only made an effort for a short while because she left George and moved elsewhere. While she was still in George's place, I went to see her, and I realized that I didn't feel the same towards her anymore. I didn't want to have sex with her, but I told myself that I was in St Petersburg, so why not? I went into her bathroom, and I saw the perfume that she usually wore. At that moment, I realized that all

my sexual excitement over her was because of her perfume, Lancôme Rose Midnight. I was shocked and amazed at how perfume could have had such an effect on me. I still use that perfume to this day, and it is my favorite; it makes me feel very sexy!

I left the bathroom, and I didn't say anything, but I realized that I didn't want to be with her as a friend. She told me about her relationship with George and how they had changed from being a loving couple to enemies. After that, I spent more time in the studio because I wanted to avoid drama. I just wanted to focus on my future. We continued the shoots, but George didn't speak to me much because he was depressed about Nadia leaving him, and he thought that I was the one who had pushed her to the other guy. That wasn't true, I had just stated my opinion, and she took it.

Nadia was still my friend, but I stayed away from her. I worked at the studio. George blamed me for pushing Nadia away from him, but I did not. I applied to a new university where I would study personnel management. I was accepted in the second year because of my studies at Tomsk. I applied to a technical university so I could be a manager in charge of people. They accepted me, and I was supposed to start school in October, but I only had to go there twice a year for my exams, unlike at Tomsk. I also had to attend a few days during the school year for some lessons and to get to know the lecturers. So, for me, this was good because I could work and still get an education. This was my plan.

I no longer communicated with Nadia as she was involved with someone new. And George hated me. So, I started a new life in St. Petersburg. I was excited to start at my new university. I worked on the webcam sites as I did in Tomsk, and I shot some porn scenes occasionally.

Once Nadia left George, he became angry with me and kicked me out of the studio. He said it wouldn't have happened if I hadn't fooled around with Nadia and encouraged her to leave him for some other guy. He texted me and told me to leave the studio immediately. I had a shoot with another studio, so I packed my things and left. I had no idea where I was going to sleep that night.

We were shooting as usual, and the camera guy asked me, "Oh, hey, how are you?" and I told him that I didn't have a place to stay. He told me that one of his friends was renting a room and that I could stay with him and split the rent. I was pleased about the offer, and I also knew the camera guy from all the work that I'd done with George. The next day he took me to meet his friend, who was about 35 years old, and he was happy for me to share the cost of the room. George wasn't talking to me because he was hurting, and I wasn't talking to Nadia because she was into another guy. I didn't want the drama, and somehow, I realized that I would be staying in St Petersburg. I didn't know much, but I knew I had to start a new life, and I was excited about going to university in October.

So, I was working on my own webcam site, I was shooting porn, and I was renting a room with this guy as a roommate. It was a big apartment with one main corridor and five rooms; in each of the rooms lived a different family. There was a shared toilet and kitchen for the five families. The guy I was sharing a room with was a scout for a porn agency — his job was to find new girls for filming! The room next to us housed some alcoholics, another room had some students, and the last one, a couple with two sweet kids who were always crying. One family next to us was usually drinking and fighting; the other one had crying children; it was like a full action

movie. With very thin walls. Also, we couldn't bring in food to keep in our room because of the cockroaches.

Every family had to clean the kitchen once a week, which was offensive to my roommate and me because we never used the kitchen. I had to live like this for two months, but it was quite interesting and extremely cheap; we paid about 50 dollars per month together. The room was about 20 sq. meters. It didn't even have room for a bed, so we had to sleep on a mattress, which was quite big, but he never tried to touch me or anything. He was happy to have me as a roommate because he didn't like living alone. We became friends because neither of us was from St Petersburg, we were hustling for money, and we didn't know what to do next with our lives. He was familiar with webcam chat, so he gave me tips on how it worked. He also spoke English and helped with translations about what customers wanted from me.

Sometimes we went out for dinner together, but we never really spent much time together, and we didn't have any mutual friends. It all reminded me of university life. The more I stayed in St Petersburg, the more job offers I got. I also started working for lots of other studios; they were more moderate studios and more romantic. From that time, I started to perform in all different types of videos.

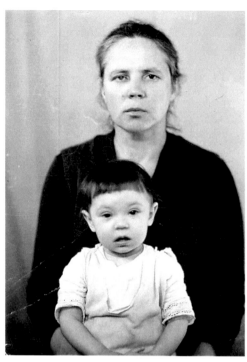

Grandma Valentina
with my mom at 1-year-old

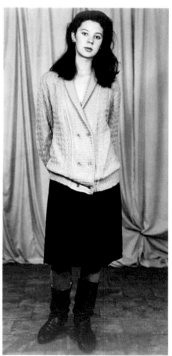

My mom at age 17

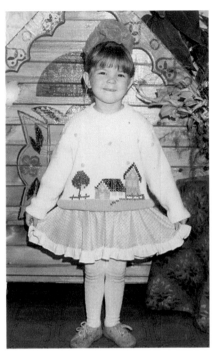

Me, at age 3

With Sergey,
my partner in crime

Graduating from kindergarten
in 1997

At age 8

Graduating from grade school

With Elena at our graduation

Striking a pose at age 14

My mom at age 27

With my mom at my high school graduation in 2009

Summer of 2009 before I left for the University

Summer of 2009

During my first year at the University in Tomsk

In the classroom

Studying in my dorm

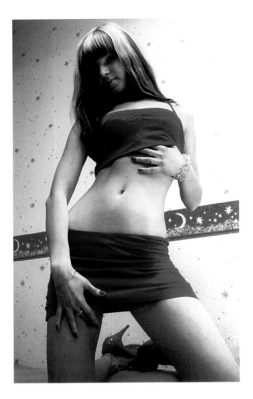

At the webcam studio

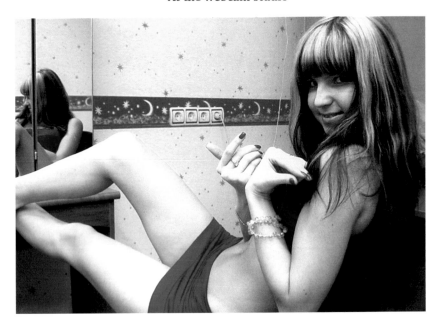

My Career in
the Adult Film Industry

I didn't hear from Nadia and George for a long time, then one day, Nadia texted me and said that she was back in St Petersburg. I didn't know then that she had been living in Prague with her new boyfriend, Constantin. Nadia said that she wanted to meet up with me, and I said that was okay. We met in a coffee shop, and she told me that she really loved her new life with Constantin in Prague, but she was lonely, and she wanted me to go there with her. She said that I could stay for as long as I wanted. I began to think that it was a really interesting idea, but I told her that I didn't have a visa. She said that Constantin could help me with that. The situation became serious when she told me that he would also help me with jobs there.

The money was great. I thought I could go to Europe and make a lot of money and then return to St. Petersburg to continue my studies. I was very excited about sex work! It allowed me to travel and meet people. I started to text Nadia less and less. I was excited about going to Budapest.

Constantin was a 40-year-old Russian, and he owned the company that George worked for. Nadia gave me his contact information to discuss the job because she really wanted me to go with her. I told her that I wouldn't go unless they had a job lined up

for me. I was chatting with him, and he said, "Hey, you are a really dangerous one. I don't like the idea that my girlfriend always talks and thinks about you." I had given Nadia a necklace with a heart-shaped pendant just to appreciate her as a good person in my life. Constantin said that she always hung it up in the kitchen, and that really made him jealous. He said, "I don't really want you to come, and I don't want you communicating with my woman, but I have an offer for you." He told me that he really knew a lot of people in Europe and that there was more money to make in porn there than in Russia. He added, "Here's the deal. If you promise never to talk to my girlfriend — no sex and no communication with her, and I can give you the contact information of two agencies which you could write to and make lots of money."

I only thought about this for a second, then I agreed. Constantin sent me an email with the contacts of two Hungarian porn agencies. I immediately wrote to them and told them that I was a Russian girl who was interested in doing porn with them. Constantin asked me not to mention anything about our deal to Nadia, so I didn't. Nadia thought that Constantin was trying to help me out as a friend and because she had asked him to, but in truth, he hated me because he knew about what happened with George. He was behaving the same way as George, he was jealous, but that was fine with me because I wasn't a lesbian. I wasn't planning on having Nadia to myself. I have never imagined living with another woman as a couple. Still, George and Constantin were afraid that I was going to take her away from them. I found it incredible that two men who were about 40 years old were afraid of 20-year-old me, and they tried to keep me away.

I didn't talk to Nadia, and I didn't tell her anything even though she kept texting me to ask me when I was coming. I began my

application for a visa to go to Europe to work, and I never told Nadia about my deal with Constantin because he really helped with the contacts. One agency replied and said that they had lots of jobs for me. They sent me a price list. I said to myself, "Wow! This is really great money, and this is definitely what I want to do." Because it was summer, I told myself that I would go to Europe, work for the agency and then come back to the university. I didn't want to spend the summer doing little jobs in St Petersburg when I could make so much more money doing the same thing in Europe. I have always wanted to do sex jobs; I exchanged my monotonous life as a student for sex work because it was an adventure. It also inspired me. There was always something new happening, and everything was interesting.

I have always been inquisitive about life, new things, and traveling, always curious about the next step to take because I was never afraid of new ideas. I was just fearless and couldn't wait to step into the future. I talked to Nadia less frequently, then I didn't speak to her at all because I had already forgotten about her. I was more focused on my new adventure in Budapest. I am still very thankful to Nadia because she was a bridge to my porn career in Europe.

Once I arrived in Europe and started working there, everyone liked me, and I had success right away. I was skinny and cute, and I took excellent care of my body. I was very proud of my body because I had always worked on it since I'd been in school. I had a little baby doll face on a beautiful athletic body. I really enjoyed the sex, and I was having a good time. Whenever I was working, I gave off great energy; everyone could see that I was happy — and people like to be around happy people. I was very skinny, but I had always been that way since my mom only cooked very healthy food at home. We avoided white bread and had lots of protein in our diet. I kept the

same weight and hairstyle I'd had since I was a teenager, and I felt very comfortable.

People would admire me because I was a cute young girl with a strong character. Sometimes I worried about people from the industry not taking me seriously, so I developed a strong character and solid business skills. I focused on my success. I thought I would only go to Budapest for three months, but my agency told me that everyone loved me in Budapest and wanted to shoot me. I started receiving more and more offers. I was excited and curious every day I went to the set. Every day, my job inspired me. I was so happy and felt like a child with a new toy. I fell in love with the climate and the place.

I was happy with my new life. I was making good money. It just didn't make sense to go back to university in St Petersburg. I was planning to enjoy my life in the industry for as long as possible, and I knew that I could go back to university if I wanted to. I was always busy in Budapest, and I built good relationships with everyone in the industry. I was like a happy kid who had arrived in a new world. I didn't feel bad about leaving Russia. I really didn't have anyone to go back to; I had no attachments. I started to feel like Budapest was my home.

I didn't speak any English yet, but people were very kind to me. I lived from month to month without making any plans. For the first year, I was very busy and traveled often. I still didn't have any friends as I didn't pay attention to my social life. I had some roommates, other girls who had come here to work. We got along well and helped each other. I started to learn English and took some classes on YouTube. I didn't have time to learn another way, and there was no one to teach me. It helped me a lot with my

communication. I realized that I was my own best friend, and I often socialized with people in the industry.

The agency made my schedule, so I never knew what I was doing from one day to the next. I couldn't really make any social plans because I didn't know what I would be doing. If I dated anyone, it was another performer. Life went on like this for a few years. I was alone, but I was never sad. I liked to study psychology in my free time because I was always interested to learn about people and why they acted and felt as they did. My brain always needed 'food,' and this meant I had to study. I also liked to do sports to keep my body in shape, so I focused on developing my mind and body. I was very interested in philosophy and human attitudes toward sexuality.

I was also curious about entrepreneurs and would read and study about them. I tried to take the best of everything I read or encountered and store it away for future reference. I loved to learn about how people become rich and successful, and I studied other people's experiences

When I was in Europe, I was working very hard. Everyone told me how hard I worked, but I didn't feel as though I was. I was just happy doing what I did, and I felt fulfilled. I always preferred to be alone than to be with those I didn't really care about. Some people still wanted to get close to me, but I was very selective about the company I kept. I did not use drugs or alcohol, and I really didn't socialize a lot. I was less tolerant when I was young. I was like a "Siberian locomotive," unstoppable. I was driven, and nothing was going to stop me! I have become more tolerant with age, but this was always a way to protect myself, so I was very selective about the people I spent time with. I liked to have only loyal people around

me, as I was really my own best friend, teacher, healer, leader, etc. No one could really fill those roles for me.

I had already been in Europe for three months, living and working in Budapest, before I told my mom. She is not an internet person, and she wasn't used to gadgets, so I knew that she would not find out what I was actually doing. I wasn't planning on telling her because I wasn't sure whether or not I was going to stay in the industry. I didn't even plan on going to Budapest, and when I got there, I didn't know how long I was going to stay; I basically had no plans that went beyond a day. That was why I decided that telling her about my adult work or school would only hurt her feelings, and I didn't want that.

My mom is a very loving person, and we have always stayed in touch, mostly through Skype; we kept in touch even while I worked in St Petersburg and Budapest. I have always been honest with her, and when I wasn't being completely honest, it was to avoid hurting her. I wasn't ready to tell her the truth because I took her feelings seriously, and I had taken the job for an adventure because I didn't have any other plans.

Then one day, Mom called me, and she was crying because someone had told her that I did this job; she felt that I was being pushed to do it because she didn't believe that I would perform willingly. One of her close girlfriends had told her, 'Hey Galena, I found out something about Valentina, and it would be better if you came to my house.' My mom went over to her house, they had tea, and she told my mom that she didn't have to panic, but she had to find out the truth from the right person. And then she showed my mom a picture of me working. My mom was shocked, she was crying, and she was panicking in a way that she had never done in

her life. She had the reaction of any mom who truly loved her daughter. She was crying and asking me to come back to Siberia.

I told her that I had been doing it for a long time. I also told her that I really liked it. It was not an easy conversation. It wasn't easy for me to find the right words to have that conversation with her. First, I let her say everything that was on her mind, then I assured her that I was okay and that I liked the job. I told her I had decided to stay longer in Europe until the work ran out. I had already realized that I couldn't get enrolled in a university at the right time in St Petersburg, so I just decided to enjoy my life and let it happen. My mom asked me about the plans I had, but I didn't have any.

We spoke every two days, and whenever I heard her voice, I could tell that she was hysterical, stressed, crying, or nervous. This was understandable because she was my mom, and I was her princess. She never said anything about disowning me; she would only say, "Come back to Siberia," but I didn't want to go back to Siberia. I kept telling her that I was okay and that I liked what I was doing. I started to send her pictures of myself having a meal, of my apartment, of my happy face. They weren't work pictures, just pictures of myself living life normally in Budapest as a happy person. I never said rude or angry words to her, but I told her that she had to accept that this was who I had become and that it was my choice, or eventually cut ties with me. She said that what I was offering was bullshit and that she was never cutting ties with me.

I continued to talk to her day after day, week after week, because I was always very patient with her. Within three months, she had calmed down, and within six months, she had totally accepted my job. It took quite a great deal of time and energy to convince her that I wasn't being pushed into doing it and that it was my choice. She

kept on asking about the university, and I told her that I had applied, and I'd be back if I was accepted. Her reaction was very understandable because no mother wants that kind of 'deviant' job for her only baby. But during all this time, we were still talking, and I always tried to put myself in her shoes; I thought of how I would feel and how I would want to be told if my own child was doing porn. It was tough.

Of course, ordinary people assume porn to be prostitution or something illegal. Very few people understand that it is clearly a business where people pay tax on their salaries and have lots of medical tests. I had to explain all these things to my mom, I had to tell her that I was healthy and that everything I did on my job was always based on my consent. We didn't talk about porn. Even now, I don't discuss sex or my sexual work with her. I just call it my job. She knows that if I'm traveling or taking trips that it is for a film shoot, and she accepts it as normal, but it was very hard at first. I was not proud of hurting her feelings, but I also felt that she needed to work on her emotions because I was my own person. I own my life, and it's up to me to make decisions about what I want in life without listening to anybody, even if it is my mom. I was very open with her, and now we are good.

I see lots of people (not just adult performers) who don't have a good relationship with their moms. I see people who can't agree or talk about simple issues, and they just go on fighting for years. This is wrong. I am someone who always wants to talk about issues; I always want to address them as they crop up because I don't want to have misunderstandings with people who are close to me. I never want to come back to the same problem twice. I see some highly successful people who are depressed and unhappy, and it is all

because they don't know how to speak up. Some people can have good conversations with others, but they cannot talk with their relatives and have really intimate and emotional conversations. They keep it all bottled up inside, and the problem just keeps on getting bigger and bigger. This is why I told my mom that I would understand if she was ashamed of me because my job is different. I also told her that other people were not better because they were having sex, and they also wanted money; in my mind, there was no moral problem.

I told her that I was satisfied because I had this opportunity, and I didn't have any psychological issues. Other people who don't have this opportunity are not satisfied with their lives. I never wanted to work under any boss, and now I don't have to; even though I work for someone, nobody bosses me. My mom drew her own conclusion from all of this, and things got better.

All of this took my mom about six months to be okay with my choices. But even when she hadn't accepted my job and she was stressed, we were still talking; we didn't have perfect long conversations, but we were talking. We were in touch once a week because I was always checking up on her. I didn't take any responsibility for her feelings, because this was my choice; I just gave her time to understand, accept, and calm down. I was always trying to reassure her and convince her that I was happy and that everything was going to be okay, and with time, I was able to make her believe me.

It was very important to me that my family accepted me and that my mom was proud of me. I put some effort into it, and it worked. This was my first victory, and I was really proud of myself because I was able to bring my family together again. This was more important

than making money because it made me feel that I could do more with my speaking skills. Calming my mother down and making her accept my choice made me confident in my communications with other people. Even when they had one opinion, and I was the only one with a contrary opinion, I was confident and happy with my own way of doing things. I was happy with my job in the porn industry.

When I was in Europe, I was traveling a lot and meeting new people. I became very curious about life in general and even picked up some English-speaking skills. I was able to have conversations in English and joke with my colleagues, which gave me more power and confidence in myself. If I could learn English by myself, I could do so much more! Self-education is very important to me because I believe that people should be able to learn something on their own without a teacher helping them. This way, you get to really appreciate your efforts. It is not the same as going to university. I feel that if someone is really hungry for knowledge, he or she should make an effort—I really wanted to speak English, so I learned it. Even when I speak broken English, I am always confident. What matters to me is that people understand what I mean, not the actual words or my pronunciation.

My work continued, I was doing a lot of shoots, but then my visa expired, and I had to leave Europe. It was winter, and I didn't want to go back to Russia because everywhere would be cold. I remembered that I had friends in Ukraine, so I went to Kyiv. While I was there, I got an offer from a local company who told me that I was charismatic and had great potential to make money, based on my personality. They recommended that I create a website to build up my fan base and promote myself as an artist behind the camera. I felt

that it was a little bit too much for me because I didn't have a team, I didn't know how to build a website, and I didn't have content creation skills. They said they would provide technical support. I didn't accept their offer immediately, and even though they kept contacting me, I felt that it was too much extra work. I was so busy with my job and all the traveling.

I had some time on my hands, so I came up with the idea of making videos of my travel experiences. I contacted the company, and they helped me set it up. They taught me how to upload the videos, helped me set up subscriptions, and designed the site for me. They asked me about my preferences, and we made corrections to the website until everything was set up. This took about a month. I had a lot of questions about the design and the colors because I really wanted the site to reflect my personality.

When I didn't shoot for professional companies, I started out with freestyle videos, just talking to fans and sharing ideas, experiences, and feelings. Little by little, I started to produce my own homemade adult content to get subscribers and comments on my photos. Some even sent me money! I also did some blog posts to share my life vision with my fans. People became more curious about me as a person, not just as a professional performer. As time went on, I began to pay more attention to the quality of my videos — mostly lighting and microphone quality. Today, my website is very successful, and I am satisfied with it. It all started as a hobby because I never wanted to spend time for no reason, and I always recorded videos when I was not working. I wanted to be productive, but I was always focused on making money. When I shoot, it is all about sharing good emotions and enjoying myself.

The site kept getting bigger and bigger, and today it is my business. Even though I never planned for the website to go beyond a hobby, I am delighted with the progress. I was never relying on it because I was trying to be productive, but today it is both a hobby and a business. When you travel a lot and stay in different places for short periods, it is not easy to keep in touch with other people. You will always have a little free time because you will rarely have people around. It was at those times that I decided to do my shoots for the website, and as time progressed, I got in contact with people who I collaborated with.

This was how I spent my free time for the first two years when I wasn't shooting, and I was also working on the design. I like pink, gray, white (one of my favorite colors), and light purple. I have always thought that there is something sexual about purple, something even more sexual than red. When I was thinking about what color I should use for my book cover, I chose purple because of its sexual connotation. Also, because psychologists say it is the color of royalty, children, and artists.

I have always been interested in studying the psychology of colors. I usually try to understand my preferences; because of this, I was curious as to why I was attracted to the color purple. I started to learn about purple and found out that it was between hot and cold — red and blue. Red is very sexual, spontaneous, aggressive, and impulsive. Blue is calm and logical. Red and blue are opposites, and if we put them together, they make purple. If there is more red in it, it becomes light purple, and if there is more blue, it becomes a cold, dark purple. This interested me because I didn't know that my choice of color meant something, and I also realized that I had always been

in between emotional and rational. Discovering that I was in balance made me more curious about the meaning of color.

Every wall in my apartment is painted white. Reading about white on the internet, I discovered that it is the color of freedom, aristocracy, and calm; and it is really calming. White is also a neutral color. It is interesting to note that everything around us is just symbols. If you know how to read the symbols, you begin to understand yourself more; and the more you understand yourself, the more you understand others. I also realized that I loved to use gray a lot — I started to think about why I loved it. I realized that it was the color preferred by smart people and people who like to live away from social scrutiny. I understood that this was the color of intelligence

Without thinking, I follow my intuition and emotions to discover why I do some things. When I find the answers, I am always satisfied. This is why purple is my color. It is the color of sexuality and artists. It represents people who are like closed books and are not usually well understood. I believe that the things around us are merely symbols. If people paid more attention to the little things around them, such as pieces of jewelry, they would learn something about themselves.

After I settled in Budapest and started traveling to different countries and experiencing different cultures, I felt like my life had changed. All my life, I was curious about money and sex, and getting into porn offered me both of these. I wanted as much sex as possible, but only good-quality sex. I didn't like to be with people who were not good at it. And I always wanted enough money to live comfortably.

I also loved power, and even if I couldn't have my own power, I liked to be around people who had it. I worked hard to train my sexual skills, and I always wanted to be my own boss. I never wanted to answer to anyone else. I accepted recommendations, but I didn't like people to give me orders. I didn't want to be around anyone who reminded me of my stepfather, Alex, who was always dominant and pushy. I refused to be around aggressive men or ones involved in criminal activity.

I never regretted leaving university. I am sure that other people who I went to school with and who are now working are not as happy as I am. I think I made an excellent choice. I took a short cut and started to earn money instead of spending five years getting a degree that would not necessarily help me with anything!

I lived for a few years in Budapest. I had an agent, a woman who was a former performer and a very knowledgeable businesswoman, Cameron Cruise, from whom I learned so much about business communication and about the adult business in general. She got me jobs with high budget, large production companies that really launched my career, and I am very thankful to her for that. I made a lot of connections through her, and I worked with her for almost five years. I felt supported and helped by her. The day finally came when I had learned enough. I felt my career had grown to the point where I could set out on my own and become my own manager, negotiate my own deals with large companies, and handle my own productions.

During those first five years, I learned the industry and built contacts. I knew that one day I would be independent. I never liked drugs, alcohol, cigarettes, or partying, and the fact that I stayed away from these helped me attain success in the business. Things changed

every year, and I always looked for good quality relationships. Porn was amazing for me; it meant money and sex. I just continued to focus on my success. I didn't want anything to do with drama and drugs. I just stayed away from people who were into that kind of thing.

I never liked drugs because I feared the effects they would have on my body. I only wanted good things for myself and to take care of myself. My psychological health was also important to me. I am the driver of my life, and how could I drive it if I was drunk? You learn in life from your own experiences. I was very selective about the people I associated with. I only liked to be with people who saw what was inside me, who had gentle souls and were kind and caring. I needed to feel safe and protected.

Once I started to do porn, I became more and more curious about sexuality and sexual life, and I thought I had a great chance to gain experience. Working with professional lovers was great for me. There was no emotional attachment or need to feel emotional responsibility for the other person. I really never liked to take responsibility for others and for their feelings. I never felt I could do that, and I always wanted to run away and be free.

When I am on the set, there will be joking and a good mood. Everyone is very friendly. We are paid to be there to have sex and to have fun and enjoy it. Sexuality always presents new things; you are continuously changing as a person. You always learn something about yourself and others. I get good quality and quantity of lovers. If I hadn't chosen porn, I would never have been satisfied with my sexual life.

Most of the actors who come to Europe are from other places. We always support each other, knowing that we are a group whose

profession is not generally accepted by society. This creates a bond between us, a kind of porn family — sex without responsibility with a significant number of lovers.

I never considered a life partner or husband as I always hungered for new places and people. I liked to do new shoots and travel. My sexual skills grew, and my knowledge of people grew. Once you are successful in the industry, you start to feel successful outside of the industry as well. By doing porn, I was able to learn and experience so many things.

I did some dating within the industry, but whenever I got an offer to marry or have children, I ran away. I just never felt it was the right time for me, so I tried to avoid relationships. Also, whenever any drama started in a relationship, I tended to leave. I wanted people to accept me and to keep a door open for me. If a door is open, sometimes I'll come back. I am not a jealous person. If I am good enough, people will stay with me; if not, they will move on. I never push people or try to get under their skin. I am happy when someone opens their heart and soul and talks openly with me. For me, intimacy is not about sex; it's about communication when we can speak freely and open our soul to someone.

I appreciate people who introduce themselves to me with both their good and bad sides. I prefer honesty from the beginning. That way, if they don't accept me, we will not waste our time. I just want to be happy and successful in life. It is always useful to network and to talk to smart and successful people. I like deep conversations about things that really matter. This is probably why I have never had a lot of friends!

I have been in many situations where people judge me by my looks. Some people think if you look young and are blonde, you are

not mature enough. I am always amazed at people who do not take the time to learn about others. But I don't let it bother me; I just don't waste my time. But I always had to work hard for people to take me seriously because of my looks, especially when I was younger.

Your Life is Your Road, You are the Driver

I do believe everything happens for a reason. Accidents are not accidental; strangers are not so strange. I imagine my life as a long road (yours too), but everyone gets a different kind of road. Mine is very unpredictable; I am always changing plans, going non-stop. Yours can be the same, different, or very different, but the idea is the same; life is the road. All the people we have in our life, on our road are fellow travelers. Some people travel with us all the way along the road, but some of them join us and leave quickly. They may be with us for a short distance, and we never see them again. Of course, it is neither good nor bad that they left us on our road, and for sure, it does not mean that they are bad people just because they left us. It means we took the best from each other, and it is time to go forward and share the best of ourselves with somebody who really needs us to be a fellow traveler.

We may meet different people who will show us life from different perspectives. This will allow us to think of ideas that we didn't have before, or they could be very similar to us and share our plans. We always benefit from meeting each other, and we share and exchange some things between us. These can be very different resources, and sometimes we may think we are only giving or

receiving information, yet we are always exchanging and sharing our thoughts. It also can happen that some of our long-time disparate, good, or not-so-good, fellow travelers show up again on the road and maybe ask for help. This just means they have something new to share with us — something that we really need right now but probably don't realize it yet. Also, their request might help us, but sometimes we don't see that, and we misunderstand the strangers' requests. However, no one joins us on our journey if we don't need them.

Sometimes we meet people who may make us even better versions of ourselves. Sometimes we need to learn the hard way because the gentle approach is unable to penetrate our wall and our illusion that all is going well. This is why a stranger may join you and leave you with bad feelings, or we leave the company of another stranger, feeling the same way. However, at the end of the day, the meeting was for a reason. Whatever happens, be thankful for the experience. It is up to you whether you grow or stay the same, but don't forget—if you always remain on the same level, you are automatically going down because time is still going up.

Also, it is funny how you love to blame others just because they did not meet your expectations, but these are *your* expectations, not the plans or needs of others. I do believe that all decisions I make in life are my own, and they are only my responsibility. I look at life calmly and don't put the blame on others. If I do something for others, it is because I want to, and not because I want something from them, no matter whether they ask for help or not. I do it from my own generous will. I am the driver of my own road. I am my own God.

I wish everyone thought the same way, and we could have less conflict and fewer problems between us. We could grow faster, develop ourselves better, and bring ourselves to a new level. Still, that is just my idea of real life. I see many people who don't like or are even afraid to accept responsibility for their own words, decisions, or actions. Many people prefer to blame somebody else rather than themselves—such as family, government, religion, environmental, climate, etc., but not themselves. I believe that people do not take responsibility for mediocre results in their lives, simply because they are not brave enough.

In our society, from the time people start school, they are educated like slaves with no opinion. Somebody, from their childhood onward, is always dictating what to eat, what to wear, what kind of university to attend after school, etc., so socially they grow like sheep, with no opinion. They are always waiting for somebody to take over and make decisions for them. This is why most people are not the drivers of their own road. However, there is still a small number of people in the minority who are brave enough to *not* be manipulated. I look around, and I see how people are afraid of anything new, something more challenging or more complicated than what they are used to. This person doesn't hear the inner voice inside him, doesn't feel himself at all, and is always afraid to make a mistake. This is why they always make mistakes and, in the end, blame these mistakes on the people who are closest to them—usually their parents. But their parents only took care of them when they were younger and not able to lead their own lives.

One day, when we have grown up and become old enough to have access to our 'driver's license,' the big road called life is ours. For some reason, not everyone becomes a driver, and that is why

they do not create their life the way they want to, but always just accept variants of what other people are offered. However, other people don't see life like you do and don't feel the way you feel. They don't have the same needs that you do, and this is why they offer you only what is good for themselves, and what they hope will be good for you. This is why you are not getting what you really like, and not what you feel you need. You don't become who you could be. You have lost yourself, leaving life for others, not for you. This is why you are not happy with your life and not satisfied.

One day, you will acknowledge your unhappy feelings but blame others for your unhappiness. You will not blame yourself for being weak, not brave enough, or hopeless. It is always sad to see how a person doesn't want to look truth in the eye, see what he rejected—his own 'driver's license,' and lost the chance to create his own road. I know it can be difficult, but it is possible to get it back. I do believe that each person should realize that his life and happiness depend on the one person who has responsibility; that is himself, and no one else. It can be difficult, but I am sure that at any age, it's possible to start living again. But if that person wants to change himself and make decisions based on his own feelings and needs, he must realize that the responsibility for each decision lies with him.

As for me, I would never let anyone drive my life and make decisions about my life because nobody feels the way I feel. No one has the same set of needs (material, emotional, and spiritual). All that I do in my life is my responsibility. I am in charge of each decision and action. I would never blame anyone else if my life became worse as a result of my actions because no one put a gun to my head and said, "Do it!" To all the people who have been in my life, whether our relationship ended well or not, I am thankful for the life lessons

and life experiences that we have had together. I believe that each person comes into my life and leaves at the right moment; at the time we need one another and when we are done with each other. Maybe it was to treat each other, perhaps it was to teach each other, but we were attracted to one other for some reason. We didn't always know why exactly, but for sure 'like attracts like,' and once we go to the next level (or one of us goes to the next level), we go our separate ways.

Personally, I'm sure that accidents don't exist; there is always some meaning or sign that we have something to learn from each other. Sometimes I learned good things from people that were helpful to me. Sometimes, I learned bad things and clearly saw who I didn't want to become. Both of these were lessons. Whatever I do with any person, the most important thing for me is not to lose myself, my uniqueness, my personality, and my inner voice. This way, I am achieving and growing my inner power, which is what moves me forward in life.

About Sex Workers
and Sexuality

As long I stay in the adult business, and I am in touch with many different kinds of sex workers, including nude models, webcam girls, adult movie performers, strip dancers, escort ladies, etc., I realize how much we all have in common and how we are different regarding our working skills—attitude, life vision, job routine, business rules, work structure. Even if it is all about sexuality, in general, we are all a part of the sex worker community. I would say we are like different kinds of fish swimming in the same ocean but at different depths. As long as I am an adult entertainment performer, I become more and more proud to be part of it. I can say with confidence that absolutely all sex workers (who take their work seriously and make a career in the industry) are strong-minded people.

First, we are strong in spirit because we remained true to our convictions and took our place in this world, occupying the niche of a sex worker according to our vocation (mission) and inspiration, contrary to public opinion that declares the low moral value of our profession, that in turn, I consider total hypocrisy and fear of expressing one's own opinion. That is why society often bows to the common opinion of the majority, since most people are cowards,

afraid to express their point of view if it goes against the general belief, purely for fear of being rejected by society! My colleagues and I are part of a social minority that is not afraid to state their point of view, even if no one supports us. We are not afraid to share our vision, even if society rejects us and condemns us. Between the choice to be like everyone else, to live according to the generally-accepted norms of social activity and morality, or to follow our own path where our soul calls us - we have chosen ourselves, contrary to the expectations of our relatives and friends! My colleagues and I decided to listen to our inner voices and do exactly what we want, not what the public is pushing us to do. We chose to live by our own rules at the risk of being rejected and not supported! And it was the only correct choice! I can confidently say that all sex workers started working in the adult industry just because they wanted to, because they love it!

The sex industry for us is inspiration and fun, where we are the masters of our own destiny. We have inner freedom; we are not burdened with stereotypes and are tolerant of people of any employment. We are not afraid of what others will think of us if our way of life and work differs from the social norms of the majority, since we were ready for this at the beginning of our careers. We are intelligent individuals, my colleagues and I. We are continually developing and learning new things, and like the majority of society, many of us have 1-2 higher educational qualifications. However, despite this, we still decided to devote ourselves to adult business, as it inspires us more, and we like to make money with our sexuality! I did not graduate from the university like many of my colleagues because I wanted to work, as I was sure that I did not need higher education to make a good living. I have always relied on my ambition, fortitude, and dedication to my own beliefs and desires.

Of course, I do not urge anyone not to attend university. I just explain that for me, the school of life was enough for me to achieve success.

Secondly, we are endowed with strong sexual energy, which, like an engine, rapidly moves us through life. Sexual energy is powerful and has an impact, not only on the personality itself but also on the people with whom this person communicates. In society, as a personality endowed with intense sexual energy, you may seem to be energetically charged and rejuvenated, gaining positivity and faith in yourself. Sexual energy provides a person with ambition, purposefulness, and invincibility of the spirit before life's trials. Sexual energy is sexual desire transformed into a high ability to survive. High sexuality is life. My fellow sex workers and I are endowed with this endless flow of life energy from nature! We accumulate it inside ourselves and share it with other people through our creativity and activity. Sexuality, the desire to be sexual, is a sign of strength and life.

You may notice that when you feel tired, sad, or sick, you are weak and seem to be mentally devastated, which is why you do not feel sexual attraction. Suffering from physical or mental fatigue, you do not feel sexual arousal and desire; you are not full of life energy at this moment; therefore, you are not capable of being sexy! You need to first restore vitality by drawing it from other resources. As soon as you feel good, your libido rises again. My colleagues and I initially have a high potential of sexual energy and can recuperate much faster. We are even able to share it as donors to restore other people - which is why you reach out to us when you feel bad and just like to communicate with us when you feel good! We are not discouraged because of our high potential of sexual energy, which is

why my colleagues and I are often cheerful and in a good mood for no particular reason.

My colleagues and I have powerful sexual energy and accumulate it quickly, which is why we need a regular release of this energy so that it does not overwhelm us — which is why we found a smart solution; to work in the adult industry! We channel the excess of our sexual energy into sexual creativity - in this way, we live a happy, balanced life and, at the same time, make a living from it. I am sure that I would not be such a satisfied and harmonious person as I am now if I worked outside the sex industry. For example, if I had graduated from university (as my mother dreamed I would) and worked there as a professor in the linguistics department or as a translator, I would not be satisfied with my life. Why? Because my sexual energy would pour from me and tear me from the inside with its power since there would be no way out for this energy!

What do we conclude from this? My colleagues and I work in the sex industry as a vocation of the soul and our physical nature, not because we could not find ourselves another place in life, as the stereotype often pronounces. I also agree partially with the judgment that sex work is an easy way to make quick money. Everyone goes for easy money in this profession, but this is possible only for a very short period if sex work is not your calling, as the adult industry is a place for people with high sexual potential. This work only makes us stronger due to the possibility of getting rid of our excess energy! Imagine if a girl or a guy with a naturally low potential for sexual energy came into this sphere and quickly used up their little sexual energy? They would be disharmonic and miserable since with a naturally low sexual potential, you cannot work as a performer in

adult film scenes - you will spend much more sexual energy than you accumulate and fall into depression! Therefore, only people with a highly erotic nature can make a career and be successful in the sex business. They dance like me and my colleagues who, just like me, get pleasure from the profession, which leads us to a hormonal balance and mental state! At the same time, we are able to share this positivity with other people through a monitor screen! You look at my colleagues and me in our films where we perform sex, and you like to watch it just because we really love to do it. Everything that is done with love and pleasure is very attractive and inspiring. So, the audience admires us, receiving a positive charge of energy and wants to watch us more and more. It's as if they are addicted to our work like a drug, and they really are! Sexuality is like a healthy biological drug without any side effects! I have never pushed or used any drugs, alcohol, cigarettes, or other dope in my life, but sexuality is a potent substance that can really control!

Hence the expression, "Sex and money rule the world." It's all about power! Sexual power is very strong, so it is able to control the feelings and emotions of people through pleasure! Pure real pleasure influences people a lot, and I have known this since the beginning of my career at the studio! The power of sexuality amazes even strong minds and attracts like a butterfly to the light. Sexual power is further enhanced when it is physically unattainable. I also realized this while working on webcams. I have always loved working in front of the monitor, pouring out the excess of my sexual energy by hypnotizing the audience with my natural pleasure of performing the show! Some will call it sexual manipulation, but I see it as a game where everyone finally got why they wanted! I got sincere pleasure from performing an erotic show. I came to work for this, and on the other hand, my viewers who came to my chat to get a visual aesthetic

erotic pleasure got what they were looking for. Plus, I made money on it, as my viewers generously thanked me for a virtual performance that inspired them, cheered them up, made them happy, and distracted them from the problems in their lives! For both parties, it was a profitable deal. It would seem that you could stop, but the power of sexual energy is much stronger than people expect!

The source of pleasure penetrates deep into the subconscious and remains there to live as long as it is needed! Since the producer of the source of pleasure was me (I performed erotic shows on webcams), it meant that they fell in love with my shows, and therefore with me! I was a source of inspiration and pleasure for the audience, so people returned over and over again to my chat for a new infusion of energy and happiness. They thanked me again and again financially, and in this way, I grew the base of people who loved me and earned my living at the same time. Since the source of my sexual energy is naturally not excised, I could delight people endlessly and sincerely. My sincerity and sincere pleasure captivated people with its uniqueness and truthfulness. It was never fake. Therefore, the people who came to me in the chat always returned, and the number of viewers who fell in love with me grew. With this, my earnings grew. I became a popular webcam model with a huge fan club. I was a success!

If you are working on webcam and want to make good money, you must really enjoy your job and love to be in charge of the process because people who watch you become more in love; not just with your physical beauty, but mostly they are amazed at your high energy, which they see through your eyes. You cannot lie when you look at the camera! The camera sees all your emotions because you

are online, on a live chat. You cannot pretend, as this is going to be easily visible—your customer will understand that you are just playing a character. You don't want to be there with them and perform fake happiness, which will disappoint them, and that is why you could make less money. Therefore, only people with high sexual energy can do this work successfully and easily fall in love with people through the monitor screen because they sincerely love it! Those who potentially have low sexual potential waste their time trying to make money. Successful webcam models really love their jobs. They love to make money through solo sex shows, and they really don't want to be touched or have sex on camera with other people. They are happy with this particular activity, so they do not intentionally enter another niche in the sex business. I really loved webcam work, but because of my too-high sexual potential, it was not enough for me to release sexual energy! I needed to not only get rid of my sexual energy, but to exchange it with a partner with the same intense energy as mine, so I was looking for ways to master a new sexual profession.

Acting in adult films turned out to be ideal for me in this case! When doing sex work, I need physical contact with my partner, so the webcam business was not enough for me. I wanted more action and more opportunities to release my sexual energy with different feeds and styles. For me, sex work in the webcam business was a show into which I put my soul and energy. I was inspired and, in turn, inspired the viewers. For me, this was important, it was not only working for the sake of money, but it was also self-realization, a way of self-expression. I and the other webcam models who made a career in this business, treated the profession as an art. I'm not talking about those who came into the business with low sexual

potential and did the work without inspiration; they usually left and did not become famous.

When I started working in the adult cinema, I was fascinated by the people around me. They were extremely passionate people inspired by their work and excited about it, like me! For my fellow porn actors and actress, performing scenes was art through which they could express themselves and show their individuality through sexuality. All actors are people born with a high sexual energy that they need to get rid of and exchange with another partner! This is a brilliant way to realize yourself and channel your excess energy into the art of sex! As soon as I entered the porn business, I realized this is the place where I want to stay because I can know myself and always arrive in a harmonious state of my soul and mind, as my energy accumulates and has the right outlet through the art of sexual intercourse where I am able to express myself as a unique personality!

My colleagues and I always take our profession seriously; the porn industry is as legitimate and as significant a business as other non-sex industry. We have the same strict discipline, and we keep records of releases of every adult film. We are responsible for our health and the health of those actors with whom we perform, and we regularly pass medical tests. We, like actors in non-sexual films, make this our career, and we also have nominations as actors of the year, best female role, best actress of the year, best foreign actress, etc. However, because of our high sexual potential, we would not be able to perform effectively and productively enough outside the sexual business; therefore, contrary to universal moral social norms and values, we chose to act in the sex industry. Although we sex workers went against the generally accepted moral standards of the

public and chose the deviant profession of a sex performer, we achieved harmony within ourselves; therefore, we achieved success in our careers.

Thus, we are satisfied with life on this basis; we are kinder, more benevolent, able to treat other people well, we are more cheerful than those who work outside the sex business without pleasure. As soon as I entered the porn industry and realized how kind and friendly people around me were, and how trusting and respectful the relationship between colleagues was, I fell in love with the profession. I feel proud that I am a part of the adult sex business. Of course, like in any other profession, we have people who are not successful in the porn industry, but this is because this is not their vocation. They do not work out of inspiration, so they do not stay in business for a long time! Of course, quick money and lots of sex sound tempting, and many people think that this is an ideal job. Still, many do not understand that this profession is favorable only for those born with a high potential for sexual energy. For others, this business can turn into a trial and torment, leading to depression and mental self-destruction because of their naturally low sexual potential. Leaving the industry, these people spread the information that the porn business broke their lives. However, from the very beginning, these people were not able and not ready to work in this area. They simply are not able to cope with the intense pressure of having sexually energetic partners and mentally break down because they are not ready for this type of activity. Therefore, I can confidently declare that sex work is not for everyone.

Successful sex workers like me are strong people, both mentally and physically, confident in themselves, not doubting their uniqueness. Since entering this business, we relied on all our

originality, showed ourselves naturally, did not copy others, and did not try to play other roles. We initially had the need to be ourselves and only cultivate our talents, develop our own sexual skills, and share them with other people. We were initially inspired by sexuality and treated sex as an art. By remaining ourselves and being true to our needs, we achieved success by principles. We made people fall in love with us naturally. When I started my website and created my own adult content, I found an even more interesting way to express myself. It began as a hobby, but I literally fell in love with this activity. I wanted to do it more and more; I never felt like I was working! For me, it is an inspiration and joy; I seem to have fun all the time. The idea that other people are happy when they see my films inspires me even more, and I want to create more. Gradually, it has grown into a substantial business and made me into an independent entrepreneur.

Since childhood, I wanted to be involved in the sex business, as I saw beauty and aesthetics in it, and most importantly, the power of sexuality that can control people. I saw some kind of film on TV, and the leading role was played by a stripper. It was an ordinary film in the daytime; fragments of her performance were shown there, and this influenced and inspired me. Of course, as a child, I did not know all the details of this profession, and I just fell in love with the picture. I now know and see the difference between each niche in the sex profession. I understand the structure and features of webcams and porn, and I find it acceptable to work in this area. Still, I would never be able to work in striptease because of the specifics of that activity. I could not work at night, for example, and I do not want to perform a show in front of a live audience. Performing on camera is ideal for me, to be an unattainable dream for people on the other side of the screen, to inspire and delight them. Of course, most strippers love

their work and would not want to succumb to publicity like me. They do not want to have sex on camera or with strangers. However, they still want to earn their sexuality, so they are inspired by their personal work and delight their audience. I would not be happy to work in a striptease setting, even if it is also an art of sexuality and the release of excess sexual energy.

I can say the same about escort services. I would not be able to work in this area, even though it implies sex and tactile contact, which I love. I do not like doing service work, and I do not get pleasure from it. I do not want to have sexual contact with people who do not have such a high sexual potential as mine. We are not equal, and I just lose myself. But I am sure that those people who have been working for a long time in the escort service love their job and they chose this deliberately. I do not advocate or idealize work as an escort now, but I want to say that these are also sex workers who have chosen this sexual niche because it suits them.

Maybe 50 or 100 years ago, if I were a porn actress, I would probably have been publicly burned at the stake as a witch. But even then, escort sex services already existed as a profession and were in demand all over the world. At the same time, this work was subject to public condemnation and disrespect, which was hypocrisy. Even 10 years ago, when I started my career in the sex industry, the audience was more critical than they are now, especially in Russia! Since the porn business is officially banned in Russia, it was also considered immoral from the standpoint of the public. I never understood why, since the activity of performing scenes in an adult film does not include activities such as stealing or killing or any other criminal activity.

Also, all people participating in the creation of content for adults have to be over 18 years old (this age is officially recognized as an adult in Russia), and all porn actors can only work if they have a fresh medical test, which is no older than three weeks. All actors and actresses take part in the filming exclusively of their own free will without any coercion. During the filming process, any of the actors can say stop or explain what he or she does not like. All erotic and porn content is exclusively on adult sites and is not freely available on social networks. So, I personally don't understand what exactly is immoral about creating and participating in adult content.

Nevertheless, there is a non-public organization in Russia that tracks new Russian actresses and begins to collect detailed personal information about them on social networks. Thanks to this, they can then find the girls' families. They collect the personal information of each girl and officially publish this, together with the erotic and porn portfolios of each new actress. They then send this news to the girls' relatives and friends through the social network. They notify not only all the relatives and friends of the girl whom they can find but also send messages to friends of friends. If the actress worked somewhere before porn at a regular job, they send her adult 'candy' there too! They call themselves Dianonymizers, which means they destroy anonymity.

Of course, not every girl, having tried working in porn, decides to stay in this business or even to pursue a career. Many do it for the sake of interest or just to make quick money one time. But after such black PR, lethal and tragic stories are heard about novice actresses. Many are disowned by friends and family, and it is not uncommon to find it difficult to find regular jobs due to (as the public says) immoral activities. Some girls, because of the actions of

Dianonymizers, have massive trauma in their lives. They did the same with me, but I was even glad of this black PR, as it dropped the burden of responsibility from my shoulders when I had to tell my mother about graduating from a university that I did not like. I did not have to hide my new activity in the adult industry from anyone anymore! I am even grateful to them, but I do not want anyone else to experience this since not everyone can survive such sharp turns in life.

Nevertheless, in 2014, I received an offer from the Civil Power party in Russia to run for Municipal Deputy in the municipal elections in St. Petersburg. At that time, I was already very popular in the adult business and was actively filming in Europe. At first, this proposal seemed interesting to me, and I agreed to listen in detail and even then, decided to participate. But when I realized that the official program of the political party was already being prepared, I understood that I would only be able to say precisely what they would write for me, and I would not have any real power. I decided to refuse the offer. The idea of developing the porn industry and cultivating the power of my influence in the world through sexuality seemed to me more attractive than being a puppet in the hands of Russian deputies. So, I gave up on the idea of getting involved in politics and focused all my attention on the porn business.

All these people are sex workers and work for money, but for all sex workers, their job is also art, and they are inspired to do it. A webcam model talks to people for money, and she shows them her body. A model gets naked and takes pictures. A stripper dances on the stage. A prostitute has sex for money, while porn actor sounds like another word for prostitute, especially in places like Russia.

Times are changing, but when I started to do porn, it was exactly like that; lots of people didn't understand the difference. They looked upon them as the same because it is all done for money. This did not affect me because I based my decisions on my own opinions and feelings, I had always worked as a soft model, and I started sex work from the webcam. This is why I can boldly talk about the job and why girls do it. Also, I was very close to the girls who did striptease. I never tried it because it wasn't my kind of thing, but I always enjoyed going to watch the girls dance on stage. I always chatted with them, and I have an idea of what goes on in their minds. I am also close to the girls in my industry, and because I am a sex worker, I am in touch with girls who escort. Even though society thinks that they are all the same, there is a big difference between them. Before I started to do porn, I was making calls on webcam and adding nude photos; I was more conservative then because I felt that it was art, and that was my limit. Whenever I sat in front of a webcam, I felt in charge of the guys that sent me tapes, of their libidos, and of how they got horny. I could continue with them or get up and tell them that I had to go; they would just feel that they'd had a bite of an apple but didn't get the whole thing. It was cool to play hard-to-get because nobody could touch me, and it felt fantastic to them. I just showed myself, teased people, and got paid. It was a pretty great job for me, and I didn't imagine then that I would ever go into porn.

I remember this because when the university kicked me out, I started staying in the cam-models studio with the other girls. There were five rooms, and five girls would sit in these rooms for the first part of the day, and during the second part of the day, I would be among the second set — this was how I got to know about them and ask them questions. Most of the girls there are really conservative,

and they don't even think of meeting their customers for sex — they don't want to be touched by anyone, and they don't want to meet anyone. This was not 100% true for all the girls, but webcam models want to do sex work because they enjoy it as a form of self-expression, but they don't want to be touched, which is why they choose webcam. This does not mean that they are prostitutes or that they have low morals. They feel safe with the idea of being visible only on the internet. And these girls did not choose this job because there was no other way of making money or because they were being silly. They chose it because they enjoyed teasing people and loved to show themselves in front of the camera.

It was exciting! I didn't even have to do it for the money; I enjoyed the process, always wore a happy face, and customers were always happy to support me. We were also thrilled with our daily earnings because we were making good money, especially as we were students. However, that was not what drove us, because there were lots of other ways to make quick money — we sort of had this need for sexual self-expression. The girls were afraid that a relative or someone from the university would find out what they did, and this was all because of social opinion because, for the girls, it was a fantastic job! I never heard any of the girls complain that they didn't like the job and had to do it for the money. There were times when they were not in the mood, though, but they had to sit down and do it because they were being paid. At those times, they usually earned less because the camera always loves a happy face. In my opinion, the camera and the customers can see your emotions. Sex work is fun, and you can make a lot of money. Once you do sex work and realize that you are paid much more than you would be paid for teaching, cleaning, etc., you really do not ever want to get out. You're happy, not only because you are getting paid, but because you are

enjoying your work. As I progressed in the industry, I discovered adult film actresses who didn't mind doing hardcore. The webcam models are not like that. They only get naked and will not even open their legs. They really want to be in the room alone; no technical crew, just them. I was that way too when I was a webcam model, but as I became more open-minded, I saw some soft-core models who did not mind the crew being in the room with them; they were still naked and posing, but didn't want anyone touching them. The new models looked at adult porn actresses as if they were doing something really crazy, and I understood them because that wasn't what they had bargained for. Each sex worker chooses the type of work that she is comfortable with.

I also talked to the girls who striptease in clubs. They are professionals who create the choreography for their dancing— and they love to dance! One of them told me that she worked in a nightclub in Moscow and that she just wanted to dance. She said that she could have sex with anyone without feeling anything for them and that it was really exhausting to work through the night and during the day as well. The primary thing for her was the fact that she felt like a goddess when she danced. People loved her and got crazily horny for her.

When I was in Budapest, I also got friendly with some of the girls there, and they explained to me that they really loved the job — they didn't even take drugs or anything. I also visited other strip clubs in Germany and London when I was free from work. As a lover of 'teases,' it was really amazing seeing all those girls who were so talented and good at their jobs. I loved that they were really professional, and I respected them for that. When I talked to some of them, they told me how they really enjoyed their work, even though

it was hard being around some impolite and drunk people. I have to correct myself though, I only visited gentlemen's clubs. But I talked to the girls because we connected as sex workers. After all, I was also a girl, and I was a sex worker! They told me that I was cute, and they wanted to know how I could have sex with people I didn't know. Some of them told me that they had worked as strippers for over seven years, but they wouldn't do porn jobs for any amount of money! I understood that because I knew that sex was not for every sex worker — you had to be born really hungry for sex and really special to have sex as a form of acting.

I have seen lots of sex workers who just have sex with their boyfriends and husbands and secretly do sex work, such as strip teasing or webcam modeling on the side. I see sex workers that have a lot of principles about what they will do and what they will not do, and I have a lot of respect for them because I feel that they know what they want in life. This is why I think it is a big mistake to call all girls that do sex work, prostitutes. I have been around them all my life, and they are people who really make a difference. They are like psychologists, really smart, and some of them have a good education.

I want to talk about girls who are building a career in porn, not just those who try it and decide to just walk away. Some girls really like porn as a career; they want to develop themselves and make a name in the industry. I am included in this group. These are people who are born with high sexual hunger and think about sex more than other people do. For us, and for me, especially, the best decision I made was to put my sexual energy into porn. I wouldn't have been able to have a normal life without becoming a sex worker. I love porn... I feel that I am in the right place and also around people like

me, who have a high sexual appetite and a great libido. It is just great to be around people like yourself, and even though we have sex without love, we do it with great respect and empathy. This is not the same as prostitution because even though we are also paid to have sex, we do it with our colleagues. We are all hired to work; we agree that we like each other; we get tested all the time, and we do the job. For us, it goes beyond the job; it is an adventure, and we are happy to do it. Escorts don't know who they are going to meet, and they don't know if they will like him. However, that is another kind of business. Escort girls also love their work, find it interesting, and prefer it to other types of sex work. I had some girlfriends in that line of work, and they are interesting and very nice people.

Sex work is a bit more complicated, but people just call it prostitution, and this hurts my feelings sometimes. In sex work, we are all employees under the care of a company; we are protected physically and health-wise. And we feel like movie stars! It is not the same in prostitution. When we go into shooting, we are not thinking about money, because we already have a contract, but how to satisfy our partners. I have some friends who are escorts, and I am often in contact with them. I see their attitude towards men and women, and they are good people.

When I am around porn girls, I feel like we are on the same team, the same level, and we are all looking for an adventure. I think we are happy because we take care of our sexual needs without any emotional attachments. We are all human, and I have had drama in my life with professional guys who fell in love and tried to get closer to me. I see a lot of support and empathy for each other in my job — it is a different world altogether. My friends who do porn do it because they enjoy it, and they still believe that they made the right

choice. Also, once you are a sex worker, you have a sense of freedom over the moral restrictions that society puts on you. You begin to hear your inner voice more clearly, and at the same time, you are mature enough to deal with it. This opens up a sense of harmony. For me, when I am working, I hear myself more, feel myself more, and live my life without thinking about what society is saying. Porn has broken many useless rules in my life, and I have found freedom and success.

Conclusively, I think all sex workers, including escort girls, do it because they want to do it. And once you are into sex work, there is usually no going back. There are different aspects to this work. For instance, I am very deeply into adult work; I do *everything* on camera, and I don't mind people around. When I meet webcam models now, I see them as shy little girls, and it is funny because I used to be like that. Although I wasn't shy, I just didn't want anybody touching me. I still think that choosing porn was an excellent decision for me. Once again, for all sex workers, money is usually secondary.

About Self-Confidence

High self-esteem beats everything: beauty (external and especially internal); broad education; mind; talents and abilities; muscle and money. Self-esteem compensates for everything: if there is no unique beauty, education, or talent, but a person is in love with himself and does not doubt his uniqueness and charm, he will definitely be happier, stronger, smart, beautiful — and even proud of himself since high self-esteem beats everything!

For example, you are a stunning blonde, with long legs, a slender figure, a beautiful face - everything is like a magazine cover photo - you are a model in appearance, and everyone likes you. However, if at the same time you are sure that your nose is too big, your backside is too small. Despite your external attractiveness, you consider yourself not beautiful enough. In which case, you have already lost out to a long-nosed, bow-legged, but self-confident, ordinary-looking brown-haired woman. Because your beautiful figure and clothes make sense only if they are combined with a good relationship with yourself!

Are you awkward, and feel that you need more education to understand something and prove to the public and your friends and family members that you are not stupid? You have already lost out

to any former C-grade student who, without any doubts or a twinge of conscience, presents himself as an expert.

You are a guy who goes to the gym, pumps his muscles, injects himself with steroids, spends a lot of money on sports nutrition and dietary supplements. All of this just to show society you are strong and amazing with your new massive body. In fact, you were just a skinny shit who was beaten by the neighbor guys in the backyard. Now you want to compensate for this. You will lose out to any ordinary guy who is confident in his charisma and strength of character.

You are a girl who is not satisfied with your natural appearance, so you have injections for lip augmentation, build up your eyelashes and hair. You even wear stick-on nails of unrealistic length in the hope that you will be loved because of your transformed appearance. Sorry, you will lose to a girl of average appearance, possibly a natural beauty, and clearly aware of this. At the same time, she fully accepts herself and her appearance. You have to love yourself! Practice this, approve, forgive, pamper, and don't compare yourself to anyone.

I believe that self-confidence is more important than one's money, status, or position in life, and whatever level of success one attains. Self-confidence is something permanent; it is something you can grow and develop. It can bring you success, money, the right associations, and partnerships, etc.

A lot of times, I hear people refer to self-love as 'arrogance,' but I simply disagree with them. I do not see self-love as being arrogant because it is not the same as placing yourself higher than other people. Being confident in your personality is about self-love and self-respect, but at the same time understanding that your actions affect people around you. You mustn't try to push people down or

treat them as though they are beneath you. You should see them in the same light as yourself. However, how they act and how they react to you is not your responsibility but theirs. You don't make that choice for them. You don't decide whether other people are better than you or vice versa. Self-love and self-respect are inherently good things that bring you up without pushing others down.

Self-love and self-respect are self-instilled. Usually, these characteristics are instilled in a child by the family; by a mom telling a child how loved and perfect he is, for example. This is why I grew up to be a successful person. Not all families give this kind of love and acceptance to their kids, so it is okay to decide that you deserve to be loved as an adult. You can tell yourself, "I deserve love, I deserve self-respect, I deserve good things in my life, and I deserve people around me who love, respect me, and never put me down." Sometimes, people who just read my posts on the internet come to me and say I have a big ego. People very often confuse egotism with self-love. I do not see anything wrong with self-love because I believe that being in love with oneself is a good idea. Egotism can destroy relationships with other people and hurt yourself also. In contrast, with self-love, you treat yourself and others with respect because you share with others what you have inside yourself. It is a perfect place to start when you're looking for success, and self-love gives you a filter to protect yourself from people who do not love and respect you.

Personally, I focus on people who come to me with love and respect, who want to exchange skills and good vibes with me. Also, when I'm hiring someone, I look only at people with good vibes who are respectful and have all kinds of good ideas. I push away toxic people; I do not let them come close to me, and of course, I am never

toxic to other people because I simply am not toxic myself! This is what self-love is about; building up harmony inside of oneself. Sometimes I wake up in the morning, and I look at myself and say, "Yes, you're beautiful, you are who you are. I love who you are, and I am always with you."

I just feel that I *need* myself, and I want to save myself. I want to keep my individuality and my uniqueness. I never want to copy other people or try to change myself just to make people love me; I want to be who I am and only attract people who live life the same way. I respect people who are original. When people do not pretend to be who they are not, when they can be authentic and true to themselves, I believe that they can build up success because they remain true to their dreams and work towards achieving them. For example, there are over a million restaurants nowadays, and out of all of them, there's only one or two that you like. Those are your favorites because they are unique, and the owners treat the restaurants with love and class. This is why we are comfortable in those restaurants; because they are well taken care of, and their customers are also treated well. Everything made with love is successful.

It is the same with people. A person who really loves and cares for himself is very attractive because this person only focuses on good things for himself. Because of this, he wants good things for the people around him. This is what we have inside ourselves that we share with the people who are around us. So, if we have self-love and self-respect, those people will feel loved and respected too. This has nothing to do with arrogance because I love and respect myself, but, at the same time, I feel very humble. Learning to be humble is also

cool because there are lots of good things that it brings. When I am direct and tell people that I'm a porn star, this acts as a social filter.

Arrogance and humility do not go together, just as arrogance doesn't go with self-love, self-respect, and self-confidence. Self-confidence is all about truly believing in the fact that you are good enough, you deserve good things, good results, and good people. Arrogance, on the other hand, is about feeling that the only way to look good, be perfect, be better, is by pushing down other people. I avoid people who think that the only way to attain success in life is by doing that.

Self-respect and humility are a great combination. I prefer to be around people who have these characteristics; they show great potential and are suitable for long-term partnerships. I think that self-love and self-respect give you self-confidence, and self-confidence brings you success because self-confidence is about believing in yourself. When a person believes in himself, he can grow and develop his talents and acquire new skills. Imagine not believing in yourself, thinking that you are not good enough and that you do not deserve anything! Without self-love and self-respect, a person wakes up to a loveless reality every day, and this can be mentally degrading. This is why I believe that self-love and respect must be self-instilled.

You must believe that you deserve the good things in life because there are so many negative opinions out there. If you don't love yourself for who you are, you will feel incomplete. I have always had my own opinions about what my life should look like. Imagine how difficult it would be for me if I tried to accept everyone's opinion! So, you need self-love and self-confidence to

bring you the power you need to move forward with your dreams and your own ideas about happiness and lifestyle.

I have always ignored society and listened to my inner voice. Society was always telling me things like, "Oh, Valentina, you have to change your hairstyle," and I would reply, "Yeah, but I like my hairstyle." I *do* like my hairstyle; it suits me, I feel right like this, and I have many reasons to keep this hairstyle. At other times they tell me, "Oh, Valentina, you need to fix your teeth because they are not straight enough. If you change them, it will be better for you." My inner voice immediately tells me, "Hey, your teeth are okay. You're satisfied with them, and you don't need to be perfect; you only need to be yourself." And personally, I feel fine just the way I am.

Those who don't have self-love and confidence accept these opinions from their peers. People have also told me to make my boobs bigger, but then, my boobs are just perfect for my body, and I love that they are real. People will always ask you to change things about yourself because they do not like themselves, so they often give you the same advice they give to themselves. They are not satisfied with themselves, but instead of dealing with it and thinking about their own lives, they go around telling other people how they should live their lives. They are always giving unsolicited recommendations and pieces of advice. And in a world full of people trying to change others, self-love and self-respect will save you and keep you focused on yourself.

Self-confidence is very powerful. I have always felt like an immortal in front of social opinion. I would not let it get me down, and I can do things that society calls impossible. I have always believed in magic, in the good things that happen, in success, and moving forward. I keep trying until things start working. I never

give up because my self-confidence is just overwhelming: I always tell myself, "Valentina, it doesn't have to be *now*, but one day, it will happen." This is how I talk to myself, even when the rest of the world is telling me to give up. If you do not have self-confidence, you will always be immobile and broken by social opinion; that is why I usually ignore the opinions of society.

Taking a break helps me pull myself together and regain my self-confidence. This works well because people will always give you recommendations, even though they do not know you. And because nobody else knows you as well as you know yourself, it is essential to focus on your own dreams and path in life. Again, self-love and self-respect have nothing to do with arrogance; they are about guarding and protecting yourself. A lot of things can happen in this world, and it is essential to protect your mind because your true power lies in your mind. How you perceive yourself in your mind makes you sexy, it makes you feel unique and different. It is essential to protect your mind and self-belief. I really think that if you do not believe in yourself, nobody will believe in you. You have to show people who you are, who you want to be, and what you look forward to achieving. It is only when you let people know these things that they will support you. When you are not particular about who you are and who you want to be, the rest of society will take you for a nobody. Sexuality helped me gain self-confidence and made me a strong person with a good opinion of myself.

I also believe that if you think that you're right, then you're right; if you think you are not right, then you're right; if you think you deserve everything, you're right! This is how I live my life. I always keep moving forward, and I always protect myself and support myself. I tell myself that I deserve the best, and I don't ever settle for

less. This is why my dreams and goals take a little bit longer to be realized, but I achieve them because of my self-confidence, my self-love, and my self-respect. I think that people need to work more on their confidence to bring them things such as success, knowing the right people, having the right friends, and the right connections. Self-confidence, like talent, is not really something that you are born with; it is something that you need to develop inside yourself. In the same way, self-respect and self-love must be learned and practiced until they become a part of you, and no one can take those attributes away from you.

I think self-confidence is more important than money and success because it is something that stays with you forever. Self-confidence brings you money, success, and everything that you desire. Even if your business, family, or marriage has been ruined, your self-confidence will help you to get back on your feet and move forward again.

Self-confidence is something that saved me from negative public opinion, negative associations, and from all the things that could have brought me down. Of course, I have sometimes been alone, but I realize that I needed those 'alone' times to hear myself and listen to myself. I feel safe when I am all by myself. For me, it is essential to be alone from time to time, just to ask myself, *who am I?* and *what am I doing?* This helps me to ensure that I am doing the right thing.

While growing up and throughout my adult life, I have seen people come and go. They have all had varying opinions about me, especially at the start of my career. Some told me, "Oh, Valentina, you are only going to be in the business for a year or two, and after that, you won't be needed anymore." Others told me that I would only be there for a short while, and afterward, I would have nowhere

to go to and no money. So many people tried to advise me, and a lot of their advice was reasonable. Still, my inner voice kept reminding me of the fact that I wanted to live life differently. And listening to myself, trying to save myself, and be true to who I am, empowered me.

Many people are afraid to be themselves simply because they want to please their friends, family, society, and others who are in positions of power. I never wanted to be part of the social crowd; I just wanted to be myself at all times and be kind to myself. And being this way made me happier than most of the people I saw around me. Self-confidence is powerful and deeply rooted inside everybody; this is what makes us the kind of people we are born to be. I think that when a person is born, he exists for himself as an individual and not for other people. However, the process of growing up, family upbringing, and societal pressure causes some to lose their individuality and become people they never planned to become.

This applied to me when my mom said that I should get married and have a baby. Other people told me to go back to university because, without it, I wouldn't be able to 'find myself.' But even though I had all that pressure from without, I chose to listen to my inner voice and do what was really important to me—be happy. I saw that the people who pressured me to do things differently were trying to advise me based on their own ideas of happiness. For example, my mom really loves kids, and for her, my having children and a family would bring happiness, but this would be for her, not me. Some of my friends told me that it would be good for me to get a university degree, but again, this was their dream, not mine. I never thought that I needed a university degree to be successful because I

believed that I could always find a way to be successful and make money.

I think some people follow society's ideas of happiness because they are not strong enough to follow their own dreams and wishes. I feel that they are suffering and living bitter lives just so that people will love them. But how can other people love you if you do not love yourself? This has always been a profound question for me. Yet, not many people are willing to discuss it apparently, because I see a lot of people who lack self-confidence. So, I believe that society sees things wrongly because they always want to copy others. However, you will always be a bad copy of someone else. It is better to be unique and true to yourself. Do not be afraid if society does not accept you!

For instance, my job seems to be very deviant to most of society, but this never scared me because I never wanted to please people. I made sure to chase my dreams, to be a happy person, and to keep holding on to my individuality. Also, people have come to me to ask if I have ever fallen in love with a person after seeing his picture or watching a video he was in. I cannot imagine falling in love with a person without actually meeting that person because, just like everyone else who sees that video or photo, we are only seeing one side of a personality. Of course, I may feel a desire to be intimate with someone who I am attracted to visually, but that doesn't mean that we are going to get along very well. It just means that we can have a friendship or a relationship. For me, falling in love with someone means falling in love with his soul, character, heart, attitude, and not just his physical appearance. To fall in love is more complicated than that because, for me, sexuality is more about character. Yes, physical attraction is great, but it can only keep me involved with a person for

a short time because I would need to discuss really personal details with them — and to have something to discuss, you need to have things in common. So yes, I can say that I have never fallen in love with someone over the internet or other virtual means.

People are quick to tell me, "You are adorable" or "You are magical." These are people who have never seen or talked to me in real life, and they believe that they know everything about me. I could never fall in love with someone because of a beautiful body or face, which is why I don't understand this kind of love — that is lust, not love. Love and lust are two different things. Also, when people say something like, "I saw your video" or "I saw your photos, you are wow! I have fallen in love. I want to marry you." or whatever. I think it is because they do not understand what love is, and they do not understand what they are feeling. I do not want someone to fall in love with me just because of my body, my face, or because of how I perform sex. These things are not permanent. Physical beauty is transient. You can be young and fresh today, but as you get older, your body begins to age. But my soul, my heart, my attitude, and my character are never going to get old. These are things that should attract people. I am not hungry for sex, and maybe that's why I am more interested in the intrinsic traits of the person that I like. And of course, it is important that people are interested in personality and character because those attributes are permanent.

Developing Inner Power

In my experience, sexuality is a critical element in success! Sexual experience allows one to know their inner-self. When we feel sexual attraction, we unknowingly reach out to exactly what or whom we feel we need. And that means this could potentially satisfy our sexual needs.

Sometimes we are drawn to the people we want, even if it conflicts with our moral values or social norms, ignoring the opinions of parents, friends, or religion. Some people are ashamed of their sexual fantasies and desires because they differ from those that their social networks and society as a whole consider normal and acceptable.

Our sexual desires are part of our inner self — individual and unique — real, and not dictated by society. Our minds naturally try to fight the forbidden desires and dubious curiosities of our bodies. However, we still unconsciously continue to reach for the desired sexual object on the physical level, or we limit ourselves to erotic fantasies and visualizations, such as photos, videos, and texts. Sooner or later, our inner self conquers the conscious self — in the most favorable circumstances. But if we don't realize the sexual experience that we want, the illusion of this desired sexual

experience will begin to grow. It will cause a person discomfort and difficulties in daily life and business in the social sphere.

Due to unsatisfied sexual desires, a person lives in the world around him and looks for an outlet for this pent-up sexual energy among his or her immediate circle of people. Usually, this leads to internal conflicts within the person himself and with the people around him.

When we enjoy a pleasant sexual experience, we come to know our real, unique selves, and we study ourselves through our sexual needs. We study our social needs through sex too! People satisfied with sex want to satisfy others with sex and also aid in social life and business. Sexually satisfied people are usually kind and tolerant.

Each person wants to experience sex or love in his or her own individual way. Until they recognize their own sexual desires, they will obey the norms imposed by society or social networks. This is a mistake, as it does not bring sexual satisfaction. It only increases stress, nervousness, and is not pleasurable. It can also lead to the suppression of sexual desire and the avoidance of sexual acts. In my experience, I believe that only a pleasant and high-quality sexual act that is emotionally relaxed leads to moral and physical satisfaction. But for quality sex, you need to have sexual experiences so that you can accumulate them and learn from your own experiences based on your true sexual needs.

This involves a process of trial and error, of studying your own sexuality. It is okay and not shameful if you are ready to learn to be better without blaming anyone for your mistakes in the process. It is even okay to start by touching yourself when you are alone to be braver before touching your partner. Once you are ready, it is good to have a partner who wants to help you gain sexual self-knowledge

and develop your sexuality. The more partners are passionate about knowing their own sexuality, the more interesting and easier the study process will become, and the results will be more productive.

To gain sexual knowledge, communication between the parties is necessary. The exchange of information about sexual preferences, feelings, and sensations during the sexual experience is vital! To communicate with a partner about sexual feelings, you need to start studying your own sexuality and be honest with yourself before you have the right to expect honesty from your partner. Acceptance of personal sexual drives and needs leads to the acceptance of the personality as a whole. After this, a person will feel emotional emancipation

An excellent lover is a self-confident person who is confident in his sexual success, therefore, securely holds his position in society. This is not a selfish person in bed. This is a person who has the ability and desire to satisfy both his partner and himself in a sexual act. Sharing his sex skills, he receives a positive reaction from his partner that stimulates a greater return. Receiving sexual energy from his partner, the second partner also wants to share it. Sex is a team game in which there is an exchange of sexual skills and techniques, which in turn cause the sexual energy of both partners to be released. Good sexual intercourse leads to feelings of happiness and pleasure. Quality sex leads to the satisfaction of both people.

Success is like a drug; once you feel it, you want more! It is essential to take note of even small victories and celebrate them in your mind. This gives you confidence and the potential to improve your results. An attempt to improve upon your achievements leads to even greater success, again through a trial and error method. It is very important to maintain patience and, most importantly, to

believe in yourself. The main thing is not to give up and not be afraid to communicate with your partner. Sometimes you will be wrong, but sooner or later, you will succeed, and she will experience an orgasm. If you look for erogenous zones with another woman, they may be in different places, so you always need to improve your sexual skills, but success will come faster through experience! Thus, through our sexuality, we develop our inner power (patience, belief in ourselves, hope for success based on the experience of previous successes). We can transfer this as a model to social life and business.

I believe that everyone should learn from their own mistakes and not from those of other people. Society forces us to learn from the mistakes of other people. However, I do not think this is the path to success; instead, it is the path to the loss of our individuality, the path to standardization! All people are unique, yet I feel that the state and society need slaves and a cowardly flock that is easy to manage. This is why social networks and television dictate rules for us about how to live correctly.

I don't have a TV at home, and I don't believe that all the information and forecasts from the media are accurate. I want my own experiences. I want to know how it feels for me in my life experience, and I want to make decisions based on my experience and not on what someone tells me! You will never know how a kiss feels until you try it yourself, no matter how it is explained. You will never understand what awesome sex is until you experience it! The problem with society is that many people have never experienced a high-quality orgasm, and they live their whole lives content with sex without a full orgasm because they are afraid to experiment! And also, because they are afraid or ashamed of sexual communication.

People do not experiment because they are afraid to make a mistake. Only brave people are not afraid to make mistakes. Mistakes are part of success because using the method of trial and error leads to success. This is a risk, but as we say in Russia, "Those who don't take risks, don't drink champagne!" Do you want to celebrate your success with champagne? If you do, you will have to take risks and come to terms with the fact that you may make a mistake the first time, and maybe the second and third time as well. The more mistakes you make, the more you study and the more options you eliminate on your path to success. Success is possible even with many mistakes along the way, only the path to it will be longer! You must not give up! Take the time to analyze your mistakes, not to repeat them, and not become discouraged. By doing this, we become stronger.

Therefore, I act on the basis of my inner knowledge of my personal needs without copying my neighbor. He or she is a different person, brought up in a different family, with a different sexual orientation, different moral values, and a different worldview in general. His or her life is not my movie. I am a different, unique person, and my life is my movie, not a rerun of someone else's!

I always say that success and happiness are in my hands alone, and I would not trust the keys to my success to other people. Not because I don't trust anyone, I like to trust, but no one else feels the same things I do. No one can understand my feelings of success and happiness but me! This is true for each person.

Once you understand your sexuality and have gained the sexual experience that has led you to sexual success, there is a desire to strengthen and increase this success. Automatically, this desire to improve upon success extends to all areas of life — sport, business,

career, social activities, and social life. You believe in yourself and in your inner power because you have experienced and tasted sexual success and understand that you can do more. You want to find new discoveries in everything. Courage is gained through experimenting, using trial and error. Because you start to understand how it works and the fear of making mistakes gradually disappears — you move to a new, higher level of personal development and life needs! This is projected onto your life as a whole. With sexual knowledge, you come to realize that everything requires practical experience, and sometimes there will be mistakes. Still, you are confident that everything will work out. Every time you succeed, you become bolder, and you already understand that failure is part of success. The main thing is to maintain patience and faith in yourself and to trust your inner feelings.

If I feel that I want to create something, and it doesn't work out, but I still can't stop thinking about it and dreaming, I need to try again! It's necessary to start somewhere, even if there is no clear plan of action. The main thing is to start, even if you think the idea is ridiculous, but you need to start moving forward! Even if the idea isn't in your budget or the right people aren't around! It so happens that in life, it is not possible to predict the development of events. It's like driving at night on an unlit road, and you only have dimmed headlights that show you the path five meters ahead. Then everything is dark, and it's not clear what's next. But driving every five meters along the road, the headlights of the car illuminate the next five meters of the road. Perhaps slowly and not too boldly, you move forward, finding out what will happen in the next five meters, but at least you are moving and not standing still! Of course, there is always the risk of falling into a hole or off a cliff on the side of the road when you can't see far in the dark. Still, it is possible that you

will reach your destination safely and securely, and you will be confused only by the darkness of the night. We won't know until we try!

You dream of opening a business or producing certain products but have no money, no human resources, or a clear plan. What do you do? You still need to start moving if you really want it with all your heart. People and money may appear, seemingly by chance. Someone who has had similar dreams may help, remembering when they were in the same position as you! I often experienced this in my life — I had to take risks and move forward slowly. Even when I made mistakes along the way, I didn't fear failure; and this is important to remember. In any case, I know that mistakes are part of success, and trial and error is one of the methods we use to achieve success.

I learned this in the sexual sphere of my life. When I believe in myself and feel that I can take risks, it means that I have gained inner power, which will give me the energy to create. When I act and strive for success, and I need help, I know there are people out there with similar goals. We can unite to increase our strength by dividing the functions to achieve success for us all. By helping others, we help ourselves—people are attracted to each other because they are unconsciously charged with the same needs and instinctively look for each other.

I often hear people say things like, "What a strong guy that is!" or "How handsome!" or "He is really powerful." Many people believe this and may even be afraid of a tall guy with a huge steroid body and lightning-fast reactions. They see a massive body and have the illusion that he has superpowers. Other men are jealous of him and dream about having the same muscular body and power.

Women look at him and believe he can protect them and be a great partner for them because he seems very strong and manly. Still, not many of them would even guess that this guy is just big but not strong. No one imagines that he is just trying to compensate for a tiny dick with his huge muscles creating the illusion that everything about him is big. Very often, these kinds of guys do not have any real physical power because they are too heavy and too slow to move. They are not good at fighting or able to protect anyone, sometimes not even able to protect themselves.

There are other examples of fake power, such as a wealthy man who buys friends, a wife, and fame. He tries to gain attention on social media and make everyone look at him to create the illusion that he has power. It is all fake. To me, this is just a lonely person using money to pretend that he has power. Don't get me wrong, I love money, and I'm glad to earn as much as I can. Yes, sex and money rule the world, but I would never try to buy friends or attract anyone in my life by using money and keep them just to show other people that I'm not alone and that I'm loved. To me, this is totally faking power. Using money to attract friends or love in order to fake happiness is really a sign of weakness. People look at rich guys with fake friends, beautiful girls around them, and a fancy lifestyle — and they believe that a rich man who can buy everyone around him must be really powerful. Most of the time, this type of man was very alone in childhood or neglected by his mother and father and had no deep feelings for anyone. He grew up with the fear that everyone was going to leave him one day or that no one would love him for real, and that is what happens. Fear is a sign of inner weakness, and to kill it deep inside ourselves, we need to face it, touch it, and conquer it. Once we conquer this fear, we become truly strong.

As I have said before, real power is inside yourself, whether or not you are rich. Because similar types attract each other, weak people attract weak people, whether they are rich or poor. Yet strong people build up a strong team or stay alone until they meet people with the same strength. It is not shameful to have had an unhappy childhood. We all cried in our youth, and we had fears growing up, but once we turn 18, our life is in our hands, and we can overcome any fears we have. Once we do that, we find our power from within, and no one can take it away from us.

The opposite is true of people who are really strong inside. Sometimes, when a person doesn't look powerful or wealthy, or because they are self-confident enough that they have no need to show it in front of others, people wrongly assume that because they don't *see* any power, they think this person is small and weak. But truly powerful people are quiet and calculating, and self-confident enough not to need to impress anyone. They know their self-worth, and they have no need to pretend to be bigger than they are.

A person's real power comes from inside. This is why I call it 'Inner Power.' Inner power is real, and no one can take it away from you once you have it. It is a strong belief in yourself that even when no one believes in you, and even if everyone around is doubting you, you should never doubt yourself. It is okay to make a bad decision, fall down, and lose something or someone, but you become stronger when you get up again and fix it. No matter how many times I fall down, the important thing for me is to get back up and become better. After every loss, I gather all of my inner power and build something much better than what I lost. It strengthens me and makes me more skilled and confident. Every time I make a bad decision, I

learn from it. I take it as a lesson because, from every bad situation, it is possible to create or learn something good.

No matter how many times I have been disappointed, I still love to trust and dream. Life is constant change — we are never the same as we were a few years ago. The powerful don't worry about the future; they just live in the present. I often see people worrying about tomorrow. This is why they are unable to enjoy today! No one knows what will happen tomorrow because we cannot control it. Relax, and believe in a good tomorrow. This has the power to calm the mind. I like to think of life as an adventure, as a game with many challenges that I enjoy overcoming.

Sometimes I don't overcome them the first time, but that's okay because I never give up. I learn what it takes to overcome some of life's obstacles a few days or even years later, when I'm better prepared and have acquired more skills. I train myself not to worry too much about the result; I educate myself to enjoy the process first. When you set a goal for yourself, and you pursue the result like a crazy person, you run the risk of a double disappointment. First, you don't achieve your goal, and second, you feel sorry for the time you spent trying to achieve the goal. This is why when I chase my goals, I move slower, and I enjoy the process. Because of this, I'm satisfied either way in the end. If I don't achieve my goal, at least I enjoyed the process, and I don't feel sorry for the time I spent pursuing it. I learn from the experience. If I attain my goal, I'm doubly happy — I enjoyed the process, and I reached my goal. This wasn't always true for me, but I'm proud that I learned it through my life experience. I want to do things only if I like them: share ideas, meet people, go on location, etc. Honestly, when I try to do something that I don't really like, I've learned that it doesn't really work out well in the end. This

is why I now know that everything should be done with love and passion.

Inner power comes from self-love and self-respect. A person with inner power knows how to love and respect others and is able to share it. Love can come in many different shapes and sizes, but love is love, and it should only be sincere love. I will never accept fake love. I will recognize it sooner or later because since I was a child, my family always showed me what unconditional love is.

Inner power means the ability to forgive both yourself and others. Forgive quickly, as this relieves everything inside you that is hurting. People with inner power know that forgiveness not only heals the person who is injured, but also the one who inflicted the injury. When you forgive somebody, you leave all the negative emotions and toxic feelings behind. I see people who just keep these things inside themselves, and year by year, they don't forgive. They remain angry, and they may eventually make themselves ill because they are holding onto grievances. It is important to forgive people. When you forgive people, you feel calmer and more relaxed; it is a kind of self-therapy, it's as if you have freed up some space in your files. It is better to fill up this space with better people and better memories. This belief is helpful for me, but something else might be beneficial for another person.

Inner power means the ability to accept people and situations as they are. If I cannot do this, I just leave and go to be with others. If no one I want to be with is around at the moment, I'm satisfied just being with myself. I enjoy my own company, and I prefer to be alone rather than with people who I don't enjoy being with. I believe that when you are in harmony with yourself, you are pickier about the

people you want in your life. This is why, from time to time, I need to be alone.

Inner power, for me, is the ability to not only help others but to accept help, and even ask for it when needed. When we help others, we automatically help ourselves. This should be clear and straightforward, but in some periods of my life, I was reluctant to accept help. At one time, I felt like the person offering it to me maybe had an ulterior motive and wasn't genuinely interested in helping me. That was not good because it taught me to distrust people, and in the process, made me wish to control everything, which stressed me mentally. I remember how I taught myself to accept help, and I learned more and more about how to ask for help, despite it making me feel weaker. This was a great exercise to rein in my ego! I forced myself, and with great difficulty, I asked for help, and I became stronger, more relaxed, and freer.

Since childhood, I have always disciplined myself, not because I was pushed or because I wanted to look good for society or another person. I just did it because I wanted to be stronger, and I believed that if I could make my own rules, then in the future, I could be my own boss. This is why all those people who were not very disciplined left my life because we did not make the best combinations.

Here is my method to develop inner power:

1. The primary way I developed my inner power was through sexuality. Through a sexual experience, we get to know ourselves as real, unique individuals. Each person wants to have sex in his own way, but until he knows his true sexual desires and needs, he will do it according to the guidelines imposed by society, even if this is not entirely natural to his or herself. Only high-quality sex will lead to physical and moral satisfaction and emancipation of the individual.

This is achieved through trial and error. Knowledge and acceptance of your sexual needs leads to acceptance of yourself as you are, and this leads to inner emancipation and inner freedom. Sexual knowledge of oneself through successful positive sexual experiences leads to strengthening self-esteem and building up inner strength by identifying oneself as a successful lover. Sexual success programs a person for success in the social sphere and in business.

2. Another way to succeed and develop inner power is to win over fear. When I am afraid of something, but I really want it, I take the risk. I prefer taking risks rather than being fearful because that doesn't bring me success – it only takes me down, and I don't want that. It is such a beautiful feeling when you win over your fear and become stronger. I used to be fearful when communicating with people, but I just moved forward with it. When I want to kiss somebody, I go ahead and do it instead of remaining afraid of rejection. The worst thing that could happen is that my ego is hurt.

3. I build up my inner power by communicating with people with strong personalities and by being friends with them. Friendship and communication with another strong personality lift us higher. Even when we stop being friends, it's because our time is over, and we have to go to another level. That is okay, but I still try to stay connected with people who have a strong personality, who have a big heart, who have a soul, and high moral quality.

4. The fourth method that I want to talk about is sport, which, for me, is not only a way to keep my body in great shape, attract people, or look good in videos and pictures – it is also a way for me to build my energy, keep myself in a good mood, and keep my adrenaline level high. When I do sports, I feel like I could do absolutely anything! For example, when I wake up some mornings

feeling lazy, I push myself to visit the gym because I know that I will feel energized by going there. Also, going to the gym is a great way to build your body into a better shape. And when I see guys who are working out, it stimulates me to work out even harder. When I finish a session, and I feel pain in my muscles, I feel like they are growing, and that's progress! I believe that sports are for building discipline and energy levels. This really helps a person achieve his goals in life, which is what success is all about.

5. Self-Discipline. So, we move further to the development of inner power. The second one is about how I grew up on my own. From childhood, I have always disciplined myself; it was not because I was pushed or because I wanted to look good for society or another person. I just did it because I wanted to be stronger, and I believed that if I could make my own rules, then in the future, I could be my own boss. So this meant that I was always a punctual person; from childhood, it drove me crazy when I had to make phone calls to people who were not so punctual, like some of my friends who were never on time, even if it was just to go to the cinema and eat some ice-cream. I have always wanted people to do as they say; words backed up with action. This is why all those people who were not very disciplined slowly or quickly left my life because we did not make the best combinations. And somehow, it also brought me into contact with people who were like me; people who were also disciplined, who had ideals, believed in those ideals, and were loyal to them. The older I got, the more rejections I got from unorganized people; this is why it is very helpful to discipline yourself. You will be able to attract similar people, and you will always be around reliable people. Self-discipline has brought me great connections and helped me build up trust. When you understand that there are other people who are just as disciplined as yourself, you are able to trust

the world more. The next thing that I do to build up my inner power, believe in myself, and to try to always be on top is to observe nature. With all the damage from society and feelings of low esteem, I believe that nature heals and cleans up the mind from toxic ideas. It is like the rebooting of a computer system; I restart my mind when I let myself be absorbed into nature.

6. To be the bigger person. I decided for myself that if I want to have peace, I have to *make* peace, and if I want to have friendships, I have to *build* friendships. This is *my* life, and I am the master of my own future. If I want something in the future, I have to make plans for it and move forward. I have always had this feeling of being the bigger person from my childhood, based on my moral quality, although I had to tone down my ego as the years went by. Being the bigger person means that I usually took the first step towards making peace, even if I was the one who was right because peace is more beneficial emotionally.

7. LEARN FROM YOUR MISTAKES. I don't get sad when something doesn't happen the way I planned because I know that I tried to make it happen. I have learned everything I know from my own mistakes. I know that society says that we have to learn from other people's mistakes, but I am not other people. I don't feel the same as other people, I don't live like them, and I didn't have the same childhood that they had; so why the hell do I need to learn from *their* mistakes? If something doesn't work, we try another way, and if it works, we keep at it. The important thing is that we don't become emotionally depressed. Life is all about experiences. Simply learn from them because even mistakes are a part of success.

8. Believe in magic. Maybe this sounds ridiculous and childish to someone but, I am fucking so serious. I just feel like believing in

magic is the key to success. People call magic lots of things; for me, it is one thing, and for another person, it may be something else. But magic is just a word, and however you want to use it; you get the same energy. I make use of this belief in magic when I have done everything that I could possibly do without a result. When all else fails, I just believe in magic! If you don't believe, it doesn't happen. I consider myself lucky that magic happens to me. I think believing in magic is a skill like a kind of high emotion that you build up in yourself. Happiness and self-belief are a choice. You are not born with them — you build them up. In the same way, believing in the possibility of magic is also a choice, I believe in it, and that's why it has happened to me.

9. Connect with nature. I really enjoy just lying on the ground and watching the sky. It is like time stops for me, I feel my body slowing down, and I am not in any rush. Slowing down is really a good feeling for me, and I feel that it is natural. I don't just love connection with nature; I *need* connection with nature. I love the mountains with snow and going to the sea, walking on the beach, and taking boat rides to faraway places. That kind of thing makes me very happy but, when I can't do all that, I am satisfied with a lake or a river. Being connected to nature is very helpful for clearing the mind of negativity and refreshing yourself.

10. Don't be afraid to say no. This happens sometimes, but we should never forget that when doors don't open for us after we knock on them, it might be a good sign that there are other doors where we would be more welcome. But many people are just afraid to walk away from closed doors because they feel that they will be losing out. However, once you walk away from a closed door, you realize that there are lots of open ones — this has worked for me.

11. Forgiveness. Having inner power means that you feel strong and believe in yourself when you feel fresh and happy. When you feel like you are your own god, when you feel something inside yourself that makes you immortal. The feeling of forgiveness is very important, not just for people that you are forgiving but for yourself. When you forgive somebody, you leave that and all the negative emotions and toxic feelings behind. I see people who just keep these things inside themselves, and year by year, they don't forgive, they remain angry. They eventually become ill. Because of that, I realized that I need to forgive people, not for them, but because I need it more. When you forgive people, you feel calm and more relaxed; it is a kind of self-therapy, and I think it should work just the same for everyone. When you forgive someone, it's like you have freed up some space in your book, and it is better to fill up this space with better people and better memories, which can bring you up and not push you down like the previous ones.

12. Take full responsibility for everything that happens in your life, both good and bad! This means that what you have in life is the result of your actions or inactions! Even if you encounter problems in your life because of other people, it is not they who are to blame but you. You let them into your life, therefore only you are responsible. Focus more on your character strengths, on all the positive aspects of your personality, and nurture them! All people have positive and negative qualities. However, the extermination of negative qualities sometimes takes some people their entire lives — and they still cannot get rid of them! Some also have a second, positive side; therefore, they should pay attention to their talent and spend time on their development. Through sexual experience, we get to know ourselves as real and unique, as each person wants to have sex in his own way. However, until he knows his true sexual desires

and needs, he will do it according to the method suggested by society, which may not be entirely natural or comfortable for him. Only high-quality sex leads to physical and moral satisfaction and emancipation of the individual, and this is achieved through experience by trial and error. Knowledge and acceptance of your sexual needs lead to acceptance of yourself as you are, and this leads to inner emancipation and inner freedom. Thus, a person allows himself to be himself. Sexual knowledge of oneself through successful, positive sexual experiences leads to the strengthening of self-esteem and building up inner strength by identifying oneself as a successful lover. Sexual success programs a person for success in the social sphere and in business.

The Meaning of Success

For me, success is not a one-time thing or something temporary; I look at it as a consciously-chosen lifestyle based on mental attitudes! Throughout my life, I periodically systematized the rules of my behavior in society; in the family, interpersonal relationships, thanks to my trial and error method. I arrived at the conclusion that this favorably affected my success in life! I must note that these conclusions are based solely on my personal experience. I don't rely on other people's life experiences, nor do I take my keys to success from other people.

Here is my system:

1. Devotion to my own views, beliefs, desires, despite public opinion or the opinion of my family and friends. Do not compare your opinions with those of the majority. Being in the minority does not mean that you are wrong! The majority is prone to making mistakes! In most cases, my opinion belongs to a minority, and I'm fine with that, as long as I am at peace myself and my decisions. This is more important to me than the opinion of society!

2. Trust your intuition and listen to your inner voice, as this is the individual real self! Unlike the brain, intuition reveals the true needs of the soul!

3. Refuse to use the word 'problem' and remove it from your vocabulary, do not use it in your speech or thoughts! It can be replaced with 'complexity,' a little difficulty.' In this way, we do not train our brains to think negatively and project it onto reality! You need to believe that everything can be solved! Try to find a way out. If this is not readily apparent, ignore the difficulty until it resolves itself or until the right solution is found! Sometimes we realize later that the problem was just in our mind and not in reality.

4. Accidents are not accidental. Everything has its time, do everything you can, and trust the process!

5. If you think you can, you're right! If you think that you can't, you're right!

6. Work should be a pleasure! Choose a profession you love, so you will never feel like you are working!

7. I treat failures with irony or laughter and move on.

8. There is *no* competition! Competition was invented by losers who were afraid to miss their place in the sun and those who eagerly strove for it, losing their own personality. Keep your uniqueness, take your advantageous position in life! If this is not happening, create it for yourself, and success will come.

9. Besides work, take an interest in life in general, and have a curiosity about new things! Add new people to your life who will bring new ideas for business

10. You can make mistakes, and that's okay! Perceive mistakes not as a drama but as life lessons. Use them to grow. The main thing is to draw conclusions from the errors and learn from them.

11. Never give up! Perseverance is the key to success! When your strength and enthusiasm have waned, but things don't improve, think it over and try one more time! If it still doesn't work out, postpone the matter for a while! It's okay to return to the topic later and ask yourself, do I really need it?

12. Develop self-confidence! You need to praise yourself for the little things and tell yourself, "Well done!"

13. For a business where you have no money or a team for development, but in which your soul lies, the main thing is to start! Even if you have no clear business plan but great passion, you need to start somewhere, somehow, even a little bit. But start! Later, you can find the money. Somehow, the right people may join you, and your business plan could show up one night in your head when you are almost asleep, but nothing happens until you start, even if only a little.

14. Be sure to help others! It doesn't matter if they are friends, relatives, or partners, but it's important to help other people. By helping others, we help ourselves! Sincere mutual support is the path to personal growth and, therefore, to success.

15. Nothing is forever. Everything passes, and everything changes! Changes are necessary both for the growth of the person and the business. Updates will be needed, and we must be prepared for these and accept them.

16. The world is changing, and systems are becoming complicated. We must keep up with these developments—constant development is the path to success.

17. According to the law of plenty (Asian philosophy), for the 'new' to come, the 'old' must be abandoned! Otherwise, there is no place for progress! I completely agree with this; when the 'old' has outlived itself and has become irrelevant, it is necessary to get rid of it and let the 'new' in.

18. Develop your inner power by developing your spiritual power. To be a successful person, your mind and your soul need to be in harmony.

19. Take full responsibility for everything that happens in your life, both good and bad! This means that what you have in life is the direct result of your action or inaction. Even if difficulties arise in life in connection with other people, it is not they who are to blame, but you, since you let them into your life, therefore only you are responsible

20. Focus more on your character strengths, all the positive aspects of your personality, and nurture them! All people have positive and negative qualities, yet the removal of negative qualities sometimes takes their entire life — and they still cannot get rid of them. Sometimes they also have a second positive side. Therefore, it is better to pay attention to your talents and spend time on their development.

About Competition

We live in a world full of competition between people. In business, people are very aggressive and competitive. They spend a lot of energy looking at what others are doing and trying to be better. Since childhood, I have never felt the need to compete with anyone. When I was a child, there were beauty contests, dancing contests, etc. I never wanted to participate as I didn't feel the need to show myself to be better than others. My main competitor was myself. I just wanted to improve myself.

At school, I saw how girls were very competitive with each other. I never felt uncomfortable when someone tried to show me they were better, smarter, stronger, or more beautiful. I never felt the need to compete with these girls. I loved other females and didn't feel the need to prove myself better than them.

I just wanted to be close to them, to support them, and to feel we had things in common. I looked at other women with admiration and respect. I wanted to feel close to other women as part of a community.

Unfortunately, most women didn't feel this way because of their insecurity. I didn't want other women to look at me as a competitor. I always tried to show them that we were friends and should help and support each other instead of being competitive. I put a lot of

energy into this! I believe, as women, we are all beautiful and unique, but in different ways. No two people are the same. I just work to improve myself for myself. To go to the gym, to read books, to meet different people.

Sometimes girls don't feel secure and are competitive. I always tried to befriend them, and most of the time, I succeed. I spend a lot of time and energy to prove that I am a friend and not a competitor. If, after a time, I do not succeed, I just have to accept that their fears are too great, despite all my kind and good intentions. I love to admire other women and to be friends with them, not to push them down by using my popularity, beauty, or brains.

Male competition is different. Men are men, but it amuses me sometimes when a man tries to compete with me. For example, when we like the same woman. Let's say there is a couple, and they have a close relationship, and I really like the woman. But her boyfriend or husband always sees me as competition. I don't see it that way. I am a woman, and he is a man. We are different and will have different roles in her life. We can both make her happy. I really think it is silly when a man tries to compete with me. It shows his insecurity.

There is another type of competitor; one in the same business. I am an entertainer/performer, and I do not see this as a competition. We are all unique people with different characters and personalities. No one can be another me! Other people are different; they have different skills, personalities, and talents, even if we work in the same industry. Because we are so different, there is no competition between us. The only competition we have is within ourselves; the only fears we have are inside each of us. As artists and performers, we are not competing.

It is ridiculous when women try to compete for a man. All that is important is who he is closest to in his heart and soul. It is OKAY if someone who doesn't love you leaves. Competition creates stress, and this leads to wrong decisions and makes you fail in what you do. It is a tool that people use to keep power over others, but it is not useful for you as an individual. I do not chase after people who are not important to me.

We should do what our hearts and souls crave. You can choose to be an accountant because you can make a lot of money, but if your heart and soul really want something else, then this is a mistake. What good is all of the material gain if inside you are unhappy, alone, and miserable?

If someone asks me what the purpose of life is, I always answer, "To be happy and to share my happiness and joy with others." It is very common to fake happiness and success to lie to others, and in turn, they lie to themselves. Inside they are lonely and depressed, and they do not know why. Many people have money and 'success,' but they are still unhappy. They focus too much on material things, and they are not happy inside. They pretend to love their jobs and the people around them, but really, they do not. It is essential to stay true to yourself. To be really happy, you need to balance everything in your life. Only then can you make others happy. For me, happiness, pleasure, and harmony within myself are important to me to keep me mentally and physically healthy.

On Happiness

Many people I meet are looking for happiness. It is natural to want happiness and enjoyment. They seek happiness from outside. They believe there is a symbiosis, but no one else can feel what you feel inside; each person sees the world in their own way. The answers lie within each of us. We just have to be honest with ourselves. Many people ask me how to find the way to happiness, and often this question comes from people much older than me. This makes me realize that maturity is not a question of age but of life experience. It is about how deeply you look inside yourself and analyze your feelings and needs. Many people follow the dictates of society and are afraid to listen to the voice inside themselves. This is a kind of insecurity. It does not matter what position they achieve in society. They can still be insecure; even people with material wealth can feel empty inside and lose their purpose in life. So, they look for these qualities in others and seek to be around them. It is fine to surround yourself with positive people, but first, happiness must come from inside you. Only then will you have harmony and satisfaction; your brain and your heart must work together. Simply being with someone who is happy will not solve your problems!

I never really sought the advice of others; I tried to listen to my soul. Sometimes you can set the wrong goals for yourself, and they are not fulfilling. If you are afraid to be yourself and trying to

impress others, you will lose yourself. You may think you look impressive to others, so you fake success and happiness. Ultimately, people will see you are fake. This is not the way to achieve happiness; it leads to depression and disappointment.

Often on social media or television, we hear about the 'keys to happiness,' and people try to guide you to attain this. Life coaches take money for nothing. They are just giving you their opinion. I don't think anyone can tell you how to be happy. Happiness is something only you can discover for yourself because we all have the answer to happiness within ourselves.

I am talking about long-term happiness. We are all 'up and down.' I do believe that people change, and their preferences change. Things that were important to us ten years ago perhaps no longer have the same meaning for us. People grow and change. Our goals change, and we have to listen to what our inner voice is telling us. Some people don't want to listen to it, but I really believe that it is essential to follow your soul.

If you are not happy, you must have the courage to make changes. No one can tell you how to be happy. There is no universal key that applies to every person. We must look deep inside and be honest with ourselves. I see how often people lie to themselves, and they are afraid to be brave. It is important to take risks. You need to seek your inner power to be bold and take risks to find happiness. You need to update yourself to connect with new people and new ways of doing things. You need to see your world through a new prism. Do not listen to society or the people around you. You are responsible for your own happiness. They can only share what works for them, and these same things may not work for you.

The majority of people pretend to be happy. This fake behavior leads to problems with things such as drugs and alcohol. If you are in harmony with your mind and soul, you are smiling inside, and this will inspire them to feel the same way. You must remove toxic people from your life to protect your inner happiness. I had this experience with someone who started to take drugs and had a different idea of happiness than I did, so I had to end the relationship. Healthy minds and healthy souls need similar people around them. Otherwise, they will push you down, even if you are a happy person.

Happiness comes from within. It can be hard work, but you need to make it a habit. You must *choose* to be happy. For me, happiness is a choice. This is a complicated matter. People try to find happiness through pills and medicines or with teachers or mentors who provide them with guidance. To be happy inside, you need to have a good relationship with your mother, a family member, or another person close to you. Your relationship with your mother is the most important as she is the one who brought you into the world and protected you when you were helpless. Many people don't have good relationships with their mothers; they don't realize that they have a role in making a good relationship with Mom — it's not all her responsibility. You can have inner happiness by having Mom as a friend; someone who accepts you as you are, and is always on your side. My happiness and success are derived from the love of my mother.

I am fortunate to have a close relationship with my mom. However, we had some problems as it was hard for her to accept my work. But we found a way to build a strong relationship. When Mom tells me I am beautiful and a good person, this sticks in my mind. I

remember everything my mom told me as a child, and she was always on my side. However, the relationship between my mom and Grandma was never that good. My grandma grew up during the war, and it was a challenging time. My grandma was a hard worker and raised my mom on her own. My mom did not get love and attention as a child, which created a lot of tension between them that lasted throughout their whole lives.

When I turned 14 or 15, I started to try to work on the relationship between them. I got all the love I needed as a child from them both. I can see the difference between those who received love from Mom and those who did not. The people who did receive it are happier inside, kinder, gentler, and more self-confident. Those who had a bad relationship with their moms are not happy inside. It is as if something is missing in their lives, but it is up to them to set aside their ego and try to rebuild the relationship with their mom. One day Mom will no longer be there. And if they don't fix it before it is too late, they will be left with emptiness.

My mom did not immediately accept my work. She loved me, and we had to agree to accept each other for who we were and for our decisions. Somehow, I found the right words to make her feel confident about my choices. I tell my grandma that my mom loves her, and I tell my mom that my grandma really loves her but simply could not give her the attention she needed. I told my mom she had to make the first step. By the time I was 16, they had started to hug each other. They had lived together before and helped each other but never hugged or kissed each other.

When I was in the adult film industry, around the age of 21, I felt happy with who I was, and I started to think more about my family. I wanted them to feel that same happiness, and I worked hard to

bring that happiness to them. As my grandma gets older and is losing her capabilities, I can see my mom is happier because she now has that bond with her mother and can help her.

Intuition means listening to your inner voice, which is essential to being happy. Society teaches us differently, telling us who we have to be and how we should act. Society tries to make us like sheep and not bring out our individuality. People who do not have good family relationships tend not to trust their instincts and their inner voice.

Some people come into our lives to teach us things. This is not random — they teach us to be better. It is up to us how we benefit from this. I do not believe that things are accidental. Everyone and everything has a purpose. We attract the people that come into our lives. We need to learn and to become better.

For your happiness, it is important how you react to negative people and toxic situations. You must brush them off, put them aside, and not internalize them and let them consume you. You start to realize how unimportant they are in your life, and that helps. It is essential not to lose interest in life, to always be searching for something, as life experience is more important than formal education. You need to have contact with people in different areas of life to broaden your horizons because they can show you life from different perspectives. They can reveal possibilities and uncover things within you that you may not be aware of. For example, I always liked music, but I never really had any connection with it. Then, when I was 28, I went to a piano recital and decided I wanted to learn to play the piano. My teacher was also a vocal coach, and it was then I realized I could sing! I never had any contact with anyone from the music industry, and I never knew that side of me. Then I

got an offer to do a music video, and everything came together. They wanted to work with me because I was beautiful and had a great attitude. This contact with people from different occupations opens new doors for you and allows you to develop new skills. You never know what it can lead to!

Building self-confidence is vital to happiness. You need to be happy with yourself for all the little things that you do. Congratulate yourself on realizing your goals, both large and small. Accomplishing the small things helps you achieve the big ones later on. This trains your brain to tell yourself that you are good and helps build self-confidence.

You need to accept change in your life. People are often afraid of change; they want stability, but time is always moving on, and change is the only constant. Change is necessary. You have to be willing to adapt to be happy. You cannot be happy by being stuck in your ways!

If you want something good and new in your life, you need to cut out something old and bad. Otherwise, there is no room for anything new. Each month, I clean my apartment, and I get rid of items that I don't use. I throw them out or give them away. I don't believe in collecting things. To my mind, that is a negative thing. For me, I know what I have and what purpose it serves. The same is true for people. You need to get rid of people who bring you down. For example, I've had friends who started taking drugs, using cocaine. When I see someone do these things that can negatively affect me, I need to cut them out of my life because they have become toxic. To be happy, I need to cut toxic people out of my life. Healthy people need good emotional quality of life.

Feelings come and go. I like to go to the forest near the city. Just outside Budapest, I can enjoy nature, see animals in the wild, and hear birds singing. It gives me so much good energy, and it costs me nothing. You need to enjoy the beauty of nature!

I am a happy person and very thankful for that. I am grateful for my family and friends because they love and support me. I know that real happiness comes from within. It takes hard work, and it does not come from outside. You need to develop good habits. Unhappiness is not normal. It is a signal that it is time to change something in your life. You need to be brave enough to believe in yourself. It is just a question of self-confidence!

Why are some people happy and others not? I believe that happiness is a deliberate choice of each individual, just as unhappiness is a choice. The decision to be happy means adopting a mindset that rejects unhappiness and works hard to train the mind to be happy. We are not born with a happy mindset. We create it for ourselves through self-love and self-respect, step by step. It is something you must work at.

I realize that many people are afraid of their own desires! I know it sounds strange, but in reality, it happens all the time—a person dreams of someone or something that they wish to have, own, or just to touch at least once. They think they would give anything to have it, and one day that dream is almost attainable. All they have to do is act, yet many people are too afraid to do so to realize their dream, or they decide that they don't deserve it. Even though they love it, they push it away, thinking that something is wrong because such great luck could not happen to them. At this moment, the person thinks of themself as a loser who doesn't deserve to have their dream come true.

I face these kinds of situations and people from time to time. I see many people who don't believe in good luck or magic. They prefer to try to find something wrong with everything rather than just accept things as they are and be happy. They reject the possibility of getting what they wanted for such a long time and keep dreaming about something even more difficult to obtain. This happens because people aren't used to being happy. Many people don't believe in themselves, and they think they don't deserve joy in life. From childhood, they have had the idea that they should work hard all their life and be satisfied with very little. They think that great things are only for exceptional people who have money, power, etc. This all comes from low self-esteem and a lack of self-confidence — which means they have no love for themselves. But if you don't love yourself, no one else is going to love you. And if you believe that you don't deserve great things in life, no one else will think so, and they will never offer! This means that you have zero chance for luck, and it is you, yourself, who isn't allowing yourself to be lucky and happy!

If you asked me if I preferred to be lucky or happy, if I had to choose only one, I would definitely say lucky. Being lucky means believing in good for yourself and expecting great things. If I have good luck one day, more good luck will follow because I believe in myself and never doubt myself! Feeling lucky is a sign of satisfaction and a small victory. It means the beginning of feeling happy. These things happen to me because I think and feel that I deserve to be happy and lucky! If I can do this, it means that anyone else can too.

Another thing is that I really don't like and cannot accept is pain, either physical or emotional. I simply don't like it, and that's why I always try to avoid it. I put aside things that could make me worry or be sad. The same is true for people. I push away those who could

bring discomfort, trouble, pain, or anything else unpleasant to my life. What do most other people do? They accept toxic people in their life, even though they bring down the quality of their life. They acquire bad habits that hold them down, and they accept pain, both emotional and physical because they secretly love it.

Many people are always complaining about life. I'm sure everyone knows at least one person around them who has been unhappy for a very long time and does nothing to change it! Do you know why? It is because this person loves to be that way and is very comfortable with their own bad luck and unhappiness. This kind of person loves to talk about any dramas or problems that happen to them. They share this information as if they are proud of being a loser, instead of thinking about how to solve the issues or start to work on them! I don't feel sorry for this type of person. They love to complain about life and make others feel sorry for them. However, they never try to solve their own problems, and getting help from others does not really help but just supports their weakness. Personally, I like to help people who want to help themselves, and even do something about it. The starting point for this is self-love. Begin to grow self-respect, realize self-worth, and believe in good luck. Set your life goals and bravely move forward without looking back! It is easy to say, but happiness requires self-love and confidence. It is always possible to build happiness by using a trial-and-error method. When you are happy, you can trust the people around you, and this makes you feel even better.

I do believe adults need magic even more than kids nowadays. Play like a baby; this is very healthy and will make you truly happy without any side effects. When I see people going to the bars or pubs after working hard, trying to get rid of stress by using alcohol and

hoping it will really help, I feel like it is just a circle of sadness — work hard, get stressed, go to a bar, get drunk as hell, then the next morning, wake up with a heavy head and go to the job again to work hard. And you call that 'life?' To me, it sounds like an unhappy hell.

I think nature really treats all of us well at any age, any gender, in any kind of occupation, in any mood. Nature always has a good influence on us. We need only take time to touch the green grass with our feet, gaze at the blue sky and watch the slow-moving clouds. It is all free, and we don't need to pay an entrance fee to a city park or a nearby village. We can find this clean air even in the city just by going to a green area full of trees and listen to the birds singing. Just sit on a bench and take it all in. When was the last time you did that? It is easy; in one hour, you will feel how much more relaxed and kinder you are to others. If it works for me, it will work for anyone! Adults forget about this kind of easy fun because they are used to going to the pub. This is a bad habit that never helps but gives the sad illusion of happiness, which is never there.

What do you find in the bar when you try to relax and get rid of stress? Other drinkers who just drive you deeper into a dark place, giving you the illusion of friendship, but in truth, they bring you down to the place where they are. They are not able to show you life on the other side, which is sweet and easy. Who are you looking to find in the bar? Are you looking for someone who will care about you, someone who will suit your personality? Or will you find someone who will use you and abuse you, then leave? I'm not talking now about just cheap places like bars, clubs, and pubs. I'm talking about all bars and drinking establishments, from cheap to luxurious. However, in the end, the result is the same, and not fun at

all. Your opinion may differ from mine, and you don't have to believe me, but I don't look for friends in places like this.

What can you see in the park? Happy kids playing together, people walking their dogs, some groups coming together for yoga. Couples having a picnic, students taking rest between lessons at university. You know alcohol is not allowed in a place like this, but you can still see happy faces and hear laughter. People just enjoy being together and spending time in nature because it is healthy and free. When I see kids playing, I want to join them, and when I see dogs, I feel I want to throw them a ball. Obviously, all these pictures have a significant influence on my mood and mind, giving me energy for the rest of the day and the possibility of making new friends. Especially when you look at the kids - they play the way they want to and the way they feel at the moment, staying real and true. Why do adults find this so complicated? We are all the same kids at heart; we just have life experience. Inside we all have a kid who is craving to be happy in a natural, healthy way.

Trust is Key

For me, trust is an essential part of any relationship: love, friendship, business, etc. I cannot remain in contact with anyone without having a minimum amount of trust, and I certainly cannot become friends with someone without a *considerable* amount of trust. I have had many different situations where someone appeared trustworthy and did what they promised. Still, deep inside, for no reason, I didn't trust that person. It was not logical, but my intuition and my inner voice said no. I have also had the opposite happen, where I meet a person for the first time. I know nothing about him or her, but I feel this is a person I can trust, with no proof needed. I am always right when I follow my intuition, and most of the time, I'm wrong when I try to fight my inner feelings. When I select friends or business partners, I always trust my feelings more than logic because our brains push us toward social standards and models of behavior. This is why people very often make the wrong choice. At the same time, our soul attracts similar souls. This is why I love to follow my inner feelings and make choices with my heart. I totally agree with the idea that 'you have to look to your heart.' I remember this phrase from the story, *The Little Prince*, by Antoine de Saint-Exupéry. I remember I read this story very late in life, when I was about 24 years old, not in my childhood like most kids. When I

finished it, I felt it was so true and so sad at the same time, but also a reflection of society, which is still true to this day.

I love to trust. When I trust someone, I feel emotionally safe; I feel peace inside, and I'm able to give more trust to others. Trust is not easy to earn and very easy to lose. Once lost, it is almost impossible to regain! I think trust is a great gift and an honor. I very much appreciate it when strangers trust me based on my words alone, and I *never* break their trust. Trusting someone's word is a risk, but it can bring great results. It makes us more open, and we start to believe in magic. Trust makes us kinder and sweeter human beings.

Many of us have had our trust broken, and it is a very painful experience. Because of this, some of us are afraid to trust again, but when this happens, and we feel ready to trust again, it is the kind of challenge that can make us better people. Only when we lose something do we truly understand its value. It is the same with trust. Yes, we are broken and feel pain, but if we use all of our inner powers and try to trust once more with different people, we able to be healed. Just as you stand up after you fall down, you need to be brave and trust yourself, even if no one does. The same is true for me. I talk about my life experiences, and I know how it feels when I trust the right people. I'm like a flower that blooms again and amazes everyone around it.

Sometimes I meet people who don't seem trustworthy because of their reputation or behavior. It takes a considerable amount of time and energy for them to prove to me that they have only good intentions. After confirming to me that they are trustworthy, and having listened to my inner voice and intuition, I give these people a chance to see how it works out. Honestly, I'm not one to trust based on words alone. I like to see action over the long term, not just for a

short period. Trust is like a medicine that helps everyone, but you need to know how to use it, and sometimes it doesn't work the first time.

I firmly believe that time is an important matter. Over time we can see clearly what was essential and what was not. For example, every one of us fell in love during childhood, and we gave a promise that when we grew up and became adults, we would marry this boy or this girl. I know I did! I'm sure many kids have done this, but when we grew up, we chose somebody else or chose no one. It does not mean we were lying or were not honest with our first love in childhood; it is just that time goes by and shows us our real preferences and needs. Time shows everything, and only in time will the truth shine like a full moon in the darkness.

We are already adults and very experienced people. However, some of us continue to give a different kind of promise, which is sometimes never done. This is not because we lie on purpose; we are just in a rush to share their feelings and hopes for the future. We plan to be together forever. We promise to love each other forever, be a friend forever, stay loyal forever, be proud of each other forever — no matter what happens. Unfortunately, we are all able to doubt the correctness of our judgments and hopes, and that is okay. It depends on many different things. Sometimes I think it is even healthy to question your own beliefs to make sure you still believe the same or to check if the other person still feels the same about you. This is why many conflicts and misunderstandings happen. After that, sometimes people break up for a few days or weeks or months. This is okay, even if sometimes it has taken a year. We all need time to calm down, think a lot, get new experiences with other people that we try to replace the first ones with. We all need time to compare,

and most importantly, we need time to confirm our real feelings to ourselves. I do believe we all need time to understand what was just an illusion, and where our real friendship, real love, real passion, and genuine loyalty was. I am positive that real feelings, trust, and respect never die. At the time, it is just growing, but as we are only human, we are allowed to have doubts. We all have that kid inside who acts a little infantile sometimes, and it is okay.

Only time shows us the things that really matter. If, after conflicts and even after a breakup, if we feel still an attraction to the same person, it is okay to go back or at least try to have a reconciliation. It is not good to fight your feelings — this way, you just build up your uncertainty and fear of being rejected by others in the future. If you feel you really want to try to get your lover back after a period of not being together, then try it. If they reject you, that is okay. At least you were brave enough to stand up for your emotions and good intentions. It is very okay to be rejected; in this way, you are free from someone who isn't going to love you enough, and your doubts about them were correct. So, time will show this is not your person. Thanks to the decision to break the relationship, you are now available for new people who will accept you for who you are.

But, if after a conflict you try to get back and your person accepts you with the same love, respect, and trust, keep him or her. Sometimes we all need time to realize what we feel and how the other one feels about us. Time is really a perfect filter. For me, words are nothing, and I don't take any promises seriously. I only trust actions, but even actions need time some time to be proven. Let's be thankful for the conflicts and the passage of time because this way, we know for sure who is strong enough to keep us and who deserves our loyalty.

About My Sexual Preferences

When I was a kid, I was very curious about both girls and boys, but there was nothing sexual about my interest. Because of my behavior and attitude at the time, the girls were not comfortable with me. When I was in kindergarten, I was more impulsive than other girls and more similar to the boys. And because the girls didn't accept me, I always played with the boys. I remember seeing a group of girls playing with dolls, and when I tried to join them, they didn't welcome me. I also remember joining a group of boys who made me feel like I was in the right place, and I ended up growing up closer to the boys than the girls.

Maybe this happened because of my family and personality, or perhaps I was born like this. I only wanted to play with dolls when I was at home; when I was out with the other kids, I wanted to be more active, play sports, and run around, but girls were a little bit passive. This might be why they were afraid of me. When I was a teenager, it wasn't so different because even though I had some girlfriends, there were more boys in my life. Some of the reasons included the fact that I was a pretty girl, and I knew how to communicate with boys — I understood them. They were also more open to me, they shared deep feelings with me, and I always felt protected with them. The girls were also pretty, but they were not all bisexual by nature. Some of them just looked at me like a competitor, and I faced a lot of

disrespect and emotional rejection from the girls. I never enjoyed being in a girls' group because they didn't show the same style of behavior as the boys' group.

I didn't enjoy conversations with girls because they always talked about unimportant stuff and gossip. Girls are not really close to each other; I think they move together just for the sake of it. Some of them saw me as their competition, and some liked me. They were not confident enough to tell me because I was prettier, smarter, and braver, and I had a great personality! I realize now that many teenagers don't have that. With the girls, I felt stress, and with the boys, I felt safe. This happened naturally, and I didn't influence it in any way. I just felt like the girls were hiding so many things from me, and the boys readily opened themselves up to me — there was no deception with them.

As I grew older, I started to feel sexual attraction for both males and females. It was obviously a question of trust because my relationship with my mom influenced this, and I used to think that all women were like my mom. She was very sweet, gentle, and soft with me; she loved me and accepted me, and I trusted her. But when I started to face reality and began to have relationships with older women, I realized that I was wrong. My relationship with my mom was deep; she was female, and I needed females in my life because I enjoyed the hugs and kisses. I never felt any sexual attraction to my mom, but I would look at other women and feel something sexual. I was disappointed when my illusion of women was broken.

All the women that I have met have been less than my mom, and all that I had with them was really just a sexual rush and action. It was only ruled by passion, and there was no deep relationship or trust. With men, it was a little bit different; when I started being

attracted to guys, it was more relaxed and comfortable. It was easy to trust them, and I never expected bad things to happen with boys. But I was always careful of the girls because, since childhood, I have never been sure of what they had in mind. Growing up, I felt that I needed both male and female energy in my life for friendship, sex, or business. On the question of sexual orientation, I have always found sex with guys something more mechanic and physical, and my fantasies with women have been more emotional.

When I fantasize about sexual acting, it is based on something more emotional, gentler, more erotic, and more about feelings. It is something about sex or around it because, with men, I want sex, and with women, I want something more profound. So, I have regularly had two fantasies. Whenever I had a little crush, it was on an adult male because I didn't take boys seriously; neither did I fantasize about them. The older men stared at me sexually, while the women looked at me in ways that communicated the fact that they liked me; they always told me that I was cute, sweet and had a great body.

Growing up, I had sex with men because I loved it, but had emotional crushes on women. However, I have to say that I chose short-term emotional crushes and physical contact with women more often. I have had more female lovers in my life — probably 65% women to 35% men. More than half of my sexual partners have been women. Considering my job in the porn industry, I have had more female partners than males because we have more female actors. This is understandable because most movies are about women. As for me, I find women easygoing, and I love to fantasize about women more than men. But it does not mean I love men less. I am just pickier when it comes to men than women. I love and need both, but I have

more crushes on women because, in men, I am looking more for stability.

We all know that women are by nature more complicated and unpredictable, and this makes them more attractive for an adventure. So, I spend more energy on women than I do on men. Every time I am with a woman, I feel emotionally elevated, in love, and intimate, but it only lasts for short periods. I need that for inspiration. When I am with men, I feel safe, and even though they don't get me flying emotionally like the women, I feel stable and protected with them.

Throughout my life, it has been the women hurting me and the men lifting me up and taking care of me. It is as if I am ready to go to any lengths for a woman while men are prepared to do that for me! And of course, I believe that men should always make the first move. I do not chase after any man, no matter how much I like him, he must chase after me. I have had different kinds of women; easygoing, complicated, sweet, bitchy, etc., yet I can't tell my 'type' of woman. I must like any type because sometimes I find myself hungry for an erotic moment with a girl that is not even pretty or an older woman. With women, it was always a secret world, and you didn't know how it was going to end; with men, it was always clear! And every time a woman hurts me, or I get tired of all the problematic stuff, I usually run to a man. I feel safer and protected with men; they take care of me, and when I heal, I run back to the women for more adventures!

Nothing is really able to keep me — not money, not possibilities or whatever. I simply fly by my emotions. I always feel grateful to the men, but when I stay with them for a while, I start longing for the females. But even with all the emotional and physical attraction to

women, I could never get married to one; I only see myself having a serious relationship with a man. I feel like I have both male and female parts, but I feel more feminine. I have never had a long-term relationship with a man because I have never felt ready, and I do not plan on spending myself and my feelings on someone that I would leave one day. It is like the story of my virginity; I was waiting to fall in love with a prince, we'd have sex and stay together forever. I fantasized about this, but it didn't happen like that, and I found out that my illusions were wrong because once I lost it, I just left the guy. And now I have a fantasy of falling in love with a man with whom I'll stay for a long time without a divorce. I make it easy for girls to get close to me but difficult for a guy, especially if he is pretending to be my boyfriend. If he comes to me and says, "Hey, let's be friends," it is easier for me because I know that friendship has a lot of possibilities — such as sex and business.

When a man is trying to win my heart, I put him through hell and give him so any challenges that he can't pass. I always ask myself why I do it, but it just comes naturally for me, and I have also seen guys pass the test. I was thinking about this, and I realized that the reason I put them through this is because I want to keep the best one. When I find that one man who deserves me, who has the same mindset, same values, vision, and is really good enough to care for me — I'll simply give myself to him. This is why I give you a million challenges, guys! I know it is not easy, but that is why I also have fewer male lovers in my life, and I never give women a chance for a long-term relationship with me. I see how guys try to pass these challenges, and I also see others who only pretend. Reality usually sets in after a few challenges!

I want someone who is strong-willed, a quality person, and someone like me. I can only discover this by trial and error. It is funny, but some guys tried to date me, and I didn't even have sex with them for about a month or two. Can you believe it? And of course, they asked me why I didn't want to have sex, and I said to them, "Are you rushing me? You want to fuck me because I am a porn star?" and they said, "No, it's because we like it." I still didn't have sex with them. I know that this was difficult for them, but there was nothing they could do. It wasn't because I didn't want to have sex with them; I just wanted to check *everything*. I'm looking for a soul mate, not sex or a great body because physical things don't last.

It is very difficult and rare, but when you find your soul mate, it may not be your sexual or physical fantasy. This is why I keep friends like that. Friendship with men is easy, but it usually takes about a year for me to start to trust them enough to become my friends. This is because I understand that I am pretty and attractive, and men want to get close to me because of their sexual fantasies. It sounds strange, but it is not easy to get close to me. People think that because I'm a sex worker, it ought to be easy, but only the sex is easy. Nowadays, sex is cheap, and I get a lot of sex in my life. This is why I want something more meaningful than sex. Sex is just a desire; it is like being hungry and eating a meal to satisfy your appetite. Getting close to a person means keeping them in my life, and that is why I check — I check their words, their attitude, and how they treat other people. I usually don't tell them anything; I just watch and make my decision. Sex is good, but it is not everything. Emotion comes and goes, sex does too, but soul mates stay forever. In friendship, relationship, and business, I look for my soul mates. In the long term, it is not easy when two people have different business interests, different life ideas, and conflicting attitudes — but it can be okay for

the short term. I still don't have my ideal man in my life, but I am not in a rush. One day I think that I would want to start a normal family with a husband and a daughter. Her name is going to be Vika.

Honestly, from my childhood until now, I have never felt as if I needed a life partner or someone next to me that I can't live without. I feel complete being alone, and I am happy being alone. I feel like I can wait for my prince; when I started getting close to 30, I started asking myself, "Hey, Valentina, why don't you have a boyfriend? Everybody has a boyfriend." That was when I realized that I didn't want to have just any boyfriend because I can have lovers to spend time with, but a boyfriend is more serious. I don't want to have a boyfriend just because I think it is time; I want to have a boyfriend because this is my person, and we are soul mates. I want us to look at each other and understand each other, and I want this person to be next to me, and not less than me, because I have high standards. I want him to be as good as I am, happy with himself alone and complete. I think that being together is about sharing happiness and love, and not because a person feels incomplete. We are born alone, and we die alone, so we need people around us just for the sake of sharing happiness. If you are not happy with yourself, you will not be happy with somebody else. I want to have a relationship that is based on love, trust, respect, and care.

I have never been with a man or woman because of money or other opportunities; I was with them because of an emotional attraction or crush, or because I felt that we thought alike. I believe that it is essential that you have something to talk about beyond sex because I think that the brain is very sexy. If you asked me what I find sexy in a person, I would say the eyes and the brain. The eyes are like the mirrors of the soul and the brain. I also notice a person's

looks. When I was younger, I focused on looks, and I ended up changing partners like clothes! To me, it was fun because I never asked myself what kind of girls or guys I liked.

I like any type of woman, but with men, it is different; I only accept gentlemen who are very interested in me, are able to make the first move, and ready to accept the challenges I give them. If they don't pass my challenge, my interest disappears because I want to have a strong-willed person, someone who is as strong as I am or even stronger. A weak man will just want to push me down so that he will feel stronger, and I don't want that. I don't support the idea of feminism, and I never equate the man to the woman because they are very different. Men are unique in their own way, and women are unique, too. I think that men should just be men and women should stay women. I do not consider men and women in the same way, and I do not like to confuse genders. I only accept quality gentlemen because I have very high standards. He has to be perfect because we won't just be fucking; we must be lovers, friends, and soul mates. We must understand each other and the business. We must be interested in each other, and at the same time, we must be separate people with our own preferences and our own space. I don't see myself as a single mother, or being single forever. I don't know where my prince is or when he is going to show up, but I have time, and before I get my prince, I am going to have to kiss many frogs! With women, things are more straightforward, and I can let them go easily, but with men, it is complicated, and I believe that good things don't come easily.

As I get older, I discover more about the kind of guys I like and the kind of people that I don't accept next to me. It is all about 'life learning' because everybody that comes through our life gives us some lessons, and it is good to learn. Now that I am close to 30, I

understand myself more, and I feel myself more because of the experiences that I have had. Maybe by 40, I will know more and have more to say. Also, the older I become, the harder it is to select men and women because I put up more filters, and I know that sex, money, and options are not enough. However, from my perspective, rich people should live with rich people and poor with poor. And honestly, I would never marry a guy who makes less money than I do. He must make more money than me because I want to see my man stronger than me and protecting me. And when we talk about a baby, he has to be able to take care of us both. I live my life well and if a man comes into my life, my life must be better; otherwise, I don't need a man. My mom keeps dreaming about me having a baby, and she even says that she doesn't have a problem with me being a single mom. But I want to have a complete family.

True love lasts forever, and we don't go looking for it because it comes when we are emotionally and physically ready. It comes when we are prepared for responsibility and ready to accept the good and bad side of others. I think that when a person goes looking for love, he or she falls into the mistake of choosing and accepting the wrong person, and eventually, problems arise. I believe that good things happen naturally, and your own person is somewhere on the planet waiting for you. You will meet him or her when both of you are ready and at the right time. It is not a good idea to rush because it will happen naturally. We keep changing with the years, and because of that, I feel that the best time for me to find love and get married is when I am close to 40. I think that by then, I will have calmed down a bit, and my libido will have too! But until then, there are lots of places that I would like to visit, there are things that I would love to do, and there are things that I would want to see. I want to have a family when I feel the need to; not before. I want to

make a baby when I want to and when I feel the need to have a baby, and not because I have to, or because all my friends have babies. I want to live life for myself first.

When I have done all the things that I want to do, when I have gotten all the experiences and tried all my hobbies until there is nothing left — then I would start talking about babies. Either way, if I end up getting married and having a baby early, I will not be happy. I will not be pleased because part of my responsibility will be to my family, and the other part will be to my inner happiness. This is not good because I want to live life for myself, and I want to have a perfect family. I don't feel ready yet, but one day I will be when the right time comes, and my Prince Charming shows up. I think it is good to have experience with men before then so that you will know the things you like and hate in men. It is learning by trial and error, making mistakes, and learning from them. I think it is risky to marry your first boyfriend because you simply don't know how to act, but I believe that if he is the right person, things will be better.

I also don't like the idea of parents rushing their children, "Hey, I think it's time for you to have a baby already." I think that people are ready for all this when the time is right; otherwise, they might end up filing for a divorce. I have actually seen a lot of people who got married early getting divorced at 40, which is all very dramatic. It is painful and expensive to go through a divorce, and there is so much drama involved—and I hate drama! I don't want dramatic people in my life; I don't want someone who loves to cry and bring emotional and physical pain to my life. A healthy relationship can only be between people who are mentally and physically healthy.

People have been asking me how long I plan to stay in the industry, and I have always said that I don't know. I know that

nothing lasts forever, and we never know what the future will bring. So, for me, it is important that I remain honest to myself and that I keep following my inner light. Each person knows what they want, and you must keep making yourself happy.

Conclusion

As a female, I think the mission of every man in a relationship is to have a gentle and caring attitude to a woman: satisfy her needs, help, support, and protect her. Otherwise, why do we need them if nowadays we can make money and be successful ourselves? Sure, to make her life even better, happier, and more harmonious, a woman is the most attractive complex and unique creation of nature. With proper care, love, and attention, she blossoms like a flower and is able to give love and warmth to the world around her! If a woman is happy, then her man will be happy too, although this does not always work the other way around! Nowadays, life has really changed a lot from the day when I was a kid. Time goes by, and new technology, progress in society and media grows quickly. With that, our lifestyle is also modified. That is fine, but I cannot help but notice that we are children of an older time, when ladies and gentlemen were real and still very welcome!

Lifestyles have changed a lot during the past 20 or 30 years. However, our needs are still the same — women want to be women, take care of their families, and to be protected. In contrast, men want to stay as they always were and act as our protectors. But today, we can see a lot of different examples, and it is going to cause disharmony for both. Yes, now a woman can work a lot and make as much money for herself as a man, and even more sometimes. She

also can make babies without the involvement of a man and raise a child by herself. She can live only for herself and spend time and money investing in her future. She can easily develop as a person and a professional, which is great! But if she does it all on her own, she will become stronger and stronger, more and more independent. Although, I think this may put her out of balance with her Yin-Yang inner harmony. It's easy to say that mentally she can become more male, even if physically, she is super attractive and extremely feminine. I see a lot of women like this in my life, and I have to tell you, I really feel a sexual interest and emotional attraction to them.

She may be a 'Lady Boss' female, but she is the boss, not only by profession, but she is also the boss at home and with friends, trying to keep her dominant position and be the leader in everything. If she is too strong, this could hurt her inner female (as we know, each girl has an inner male and female inside, while each boy also has male and female sides). Because of this, men are becoming weaker, as women don't allow them to be strong enough and perform the classic male functions, such as giving protection. A man loses motivation when a woman acts like a man. Finally, they exchange roles, which is wrong. Both are unhappy, as everyone performs a role that nature did not originally create for them.

I was thinking a lot about why I love strong females and, at the same time, don't get too close to them. I finally found the answer — I love them because they are like part of me as a female but are mentally very strong. I love the male energy they have! Let's say they are a man in a female body but a woman with male goals, feminine energy with male attitude — very confusing but so attractive. Every time, I easily fall in love with them on an emotional level, but always run away. In the end, they are only a sexual adventure, desire,

fantasy, but not for a real, long-term relationship. Anyway, this topic was fascinating to me, and I wanted to understand why they are so strong yet so weak at the same time.

I realized that they are too strong. Not because they want to be, but because they have to be that way for protection, to feel safe, both physically and emotionally. Whenever I become really close to them, I see how gentle and sensitive they are inside. They are mentally becoming the men that they wish to have next to them, which is a kind of compensation. But they become so bossy and controlling that no one can be near to them and simply breath free. I think this kind of woman needs a tremendous amount of love and care to handle the inner woman inside. Even an independent woman needs and wants to get help, care, and support from the male to simply feel female, no matter how strong and successful she is. I definitely think that nowadays, many women like me need a man for true love—someone who really cares and makes her life easier, comfortable, and safe. A strong woman will not settle for anything less than a strong, caring man. No one needs a guy who pushes her down and makes her life more complicated—a woman can make her life complicated all by herself!

Even with my job and lifestyle, I still love the idea of ladies and gentlemen in a classic way; how it used to be. Only with a real gentleman can a real lady exist, I think, and only with the right man around can a woman bloom like a flower and share her femininity as a gift. I don't know much about feminism, and I don't want to hurt the feelings of the women who support it. Still, I do believe that feminism is a kind of cry for help and a huge need for love—a type of protest against the wrong attitude of men toward women, not against all men in general. I think that when a man is strong and

takes responsibility as a gentleman, a woman automatically becomes more feminine, gentle, and thankful because she feels protected and able to give more love to the one man she needs to be happy. I am sure the man can only be really happy when he makes a woman happy. A happy woman equals a happy family!

When a woman performs male functions in life, a man loses motivation and the skills to show himself as a man, such as perseverance, courage, and initiative. This disharmony of the sexes leads to serious problems in sexual intercourse. Men begin to be afraid to take the first step towards strong women, thereby becoming weak themselves. At the same time, women still expect initiative and actions from men. However, without waiting for them, the women make an effort themselves, thereby violating the laws of nature that man is a hunter. At this stage, sexual communication follows the path of imbalance and disharmony, with overly forceful women and indecisive men. Thus, a woman is not able to receive proper sexual satisfaction from a man. She cannot fully manifest her femininity and receive from a man the necessary flow of her male energy in order to feel satisfied.

Sexual dissatisfaction is superimposed on social life. Not receiving sexual satisfaction from a man as the complete sexual fulfillment manifested in orgasm, she compensates for this by herself. This gives her the means to achieve everything on her own. This response develops the habit and skill of being independent in the social sphere, in everyday life, and in business. Women who are sexually dissatisfied with men subconsciously begin to disrespect them.

In contrast, men who have failed to prove themselves sexually masculine lose self-confidence, not only sexually, but also in the

social sphere and in business. Thus, we have a disharmonious world of strong women and weak men, where everyone does not feel satisfied. This is not right, since nature intended it to be the other way around. I believe that the world lacks sexual literacy and correct sexual communication between men and women.

I feel like something wrong is going on with the sexual education of people throughout the world! I even can see on YouTube and other entertainment channels some disinformation about how to please the female body. Of course, this is not only mainstream but also some adult content that does not give the correct information to not very sexually-experienced people. Adult movies are just entertainment, not education! I can see so many posts and videos on social media about how it is cool to be 'Macho,' and even some courses teach how to become perfectly 'Macho'! These are simple lessons — instructions on how to quickly pick up girls, lie to them, use them, sexually abuse them, and leave them with broken hearts and no enjoyable sexual experience.

It's evident that these videos were made by people with no self-confidence and without any idea of how to properly enjoy the sexual act. They may have no real-life sexual experience but have great ambition, a desire to prove to everyone how great they can be in bed, and are compensating for their inferiority complexes. And what good is that in the end? Where is the emotional part of sexual experience which brings good feelings?

Sex is a team game, and each player should be interested in the pleasure of the other! If you want to have real healthy pleasure, you should have only good intentions toward your partner and be ready to treat your partner well. No question of selfishness; forget about that if you want to have healthy and productive sex.

I think the world needs more great lovers.

As I am a woman, I know how women feel, what they need, what they are ashamed to talk about, what whey lie about, how they want to be pleasured during sex. I deal with female bodies a lot, and I have learned and improved my lesbian sex a lot. I am very proud of this as I always wanted to understand how to satisfy the female body! I have excellent skills and the ability to give satisfaction to any females, as I am female, and now I want to teach both males and females about how to please and give satisfaction to the female body! I am about to open a new website called Power2BeLover.com, where I am going to give love lessons and instruction about sexual communication—with examples! This is very important for emotional connection and self-confidence!

Self-confidence is essential to have a successful sexual life! When you are self-confident, you are open to more experiments in sex, and if your lady feels how self-confident you are, she will trust you quickly and let you do it!

As a sex coach, I explain how the female body works in order to get maximum pleasure from sex because I want you boys and girls to be braver and self-confident to try it in real life with a real partner! When you have the right information, try it, and become successful in sex. You will start feeling like you can do more in your social life and business! I can see from my experience how high sexuality brings me success in each part of my life, especially in communication. Self-confidence is the key to any success. I believe and can see that self-confidence brings success, success brings satisfaction, and satisfaction brings kindness. I want this world to be more kind to people. They say, 'Beauty will save the world.' But I think kindness will do the job!